RIVER TYNE

Steve Ellwood

AMBERLEY

This book is dedicated to my wife, Joan.

First published 2015

Amberley Publishing
The Hill, Stroud
Gloucestershire, GL5 4EP
www.amberley-books.com

Copyright © Steve Ellwood, 2015

The right of Steve Ellwood to be identified as the Author of this work has been asserted in accordance with the Copyrights, Designs and Patents Act 1988.

ISBN 978 1 4456 4061 7 (print)
ISBN 978 1 4456 4094 5 (ebook)

British Library Cataloguing in Publication Data.
A catalogue record for this book is available from the British Library.

Typesetting by Amberley Publishing.
Printed in the UK.

CONTENTS

BACKGROUND TO THE BOOK

This is the first book that I have written. It is something that I had always promised myself to achieve when I retired from the Civil Service. Since the 1970s I have taken an avid interest in the local history of Newcastle, Tyneside and Northumberland, additionally photographing the changing architectural faces of those areas. My online collection stands at around 35,000 images and can be accessed via www.steve-ellwood.org.uk.

The compilation of the book has enabled me to add to my knowledge of the Tyne Valleys, something perhaps I would never have achieved in normal circumstances.

My interest in local history extends to my role as a guide with the Association of Newcastle City Guides which offers tours and walks through Newcastle, Gateshead, Tyneside and beyond.

ACKNOWLEDGEMENTS

Thanks go to Mick Sharp and the Robinson Special Collection at Newcastle University for permission to use their fine maps of the course of the Tyne. To Mick Quinn for allowing use his image of the marker stone at the source of the South Tyne. Special thanks to Jenny Stephens and Tom Poad at Amberley for their support and understanding.

INTRODUCTION

The aim of this book is to give the reader an idea of what can be seen on a journey that navigates the three rivers of the North Tyne, South Tyne and Tyne from their sources to the North Sea. Hopefully it will lead to readers wishing to visit the locations in person to appreciate the true beauty of the river valleys. Throughout the book I have tried to describe some of the more interesting features, villages, towns and city along the route. One feature of all the river courses is that they are fairly easy to follow by road and, for the more energetic, by foot or cycle. Many official walking and cycling tracks run alongside the rivers, such as the South Tyne Trail, Keelman's Way and the Hadrian's Cycle Way to mention just a few.

All too often the Tyne is associated with Newcastle upon Tyne and the shipyards of the lower Tyne, and sometimes described in poetry and song as 'The Coaly Tyne'. However, it is much more than that and I hope that misconception is dispelled by the book.

I have tried to give the meanings for the various place names mentioned; it's always intrigued me how a town or village got its name and why it is physically there. In the case of many of the locations, the names go back to the Old English and the reasons for their location beside the river being numerous, including access to drinking water, industrial use, being next to a fording or bridge crossing. It is unclear as to where the name Tyne comes from, it may come from the Celtic word meaning 'dissolve' or 'flow'. There is a river of the same name in Scotland, rising in Midlothian which also runs to the North Sea. The name 'Tyne' has been used in a variety of other ways; it is a first name as well as a surname, Tyne Class Lifeboats, and Tyne is used as an area description on the British Shipping Forecast.

William James Palmer in his book *The Tyne and its Tributaries*, makes this description of the river:

> The Tyne stands only for the trunk of the river tree, the two main streams which unite to form it, and all the other branches have their own names; the rivers North and South Tyne, the Allen, Reed, Nent, Derwent and Team, besides lesser streams and burns and dykes, whose name is legion, though but parts of an individual whole. Its bubbling spring is as truly Tyne as its broadest reaches below bridge, the child is the father of the man.

Looking from above and taking in the full length of the rivers, it would indeed look like a tree, the top branches being in Cumbria and Northumberland, the roots in the North Sea. There are so many tributaries to the Tyne that it would require a much larger volume of this book to fully describe them.

So here is the book in which I describe my journey through Tyne & Wear, Northumberland and Cumbria during the summer of 2015.

THE NORTH TYNE – KIELDER TO WARDEN ROCK

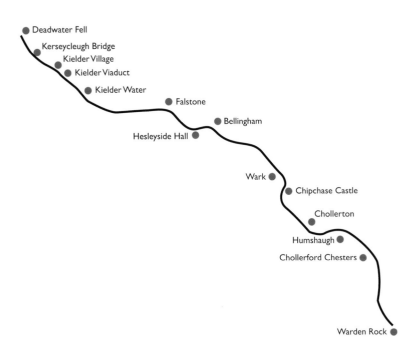

Source of the North Tyne

The source of the North Tyne is generally accepted as being a spring forming from Jimmy and Fiona Hall's farm at Deadwater Fell. Located just inside the English side of the English border with Scotland, the source is accessible on the C200 road to the north-west of Kielder village. If visiting, look out for the signs marking the English–Scottish borders, then stop at the layby and the source can be accessed via a style in the wall and a short walk over a rough path.

A 13-feet-high sandstone marker was installed at the site in October 2013, sponsored by Kielder Water and Forest Park Development Trust and the Daft as a Brush Cancer Patient Care Charity. Gilbert War sculptured the piece of art, which, due to the location of the site, was airlifted in by a Royal Air Force Chinook helicopter.

Above: Map of River North Tyne (not to scale).

Opposite: Source of the North Tyne sculpture.

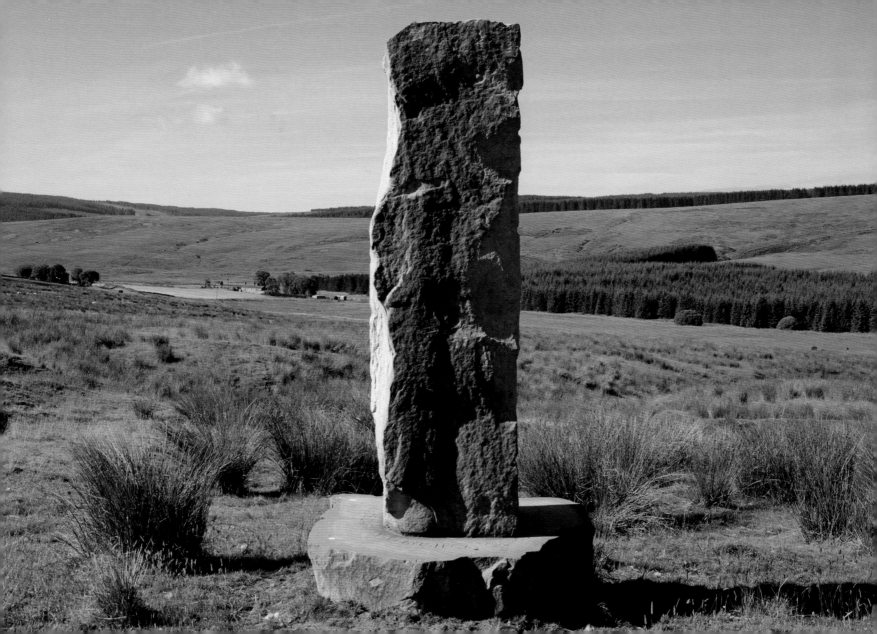

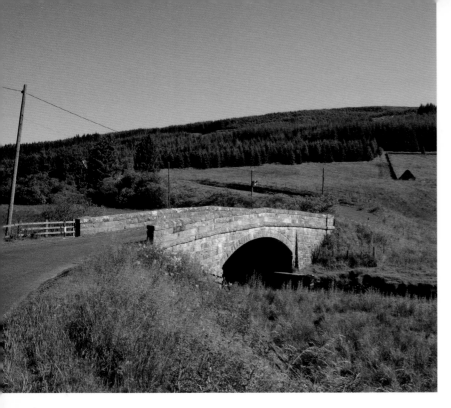

Kerseycleugh Bridge

The first of many road crossings of the North Tyne is Kerseycleugh Bridge. By this stage the river has evolved from a slow spring into a fast running course, having been joined by run off waters from Deadwater Lakes and Bells Moor, with the peat giving it a rich brown colour.

Above: Kerseycleugh Bridge in the summer.

Opposite: Towards Deadwater Lakes.

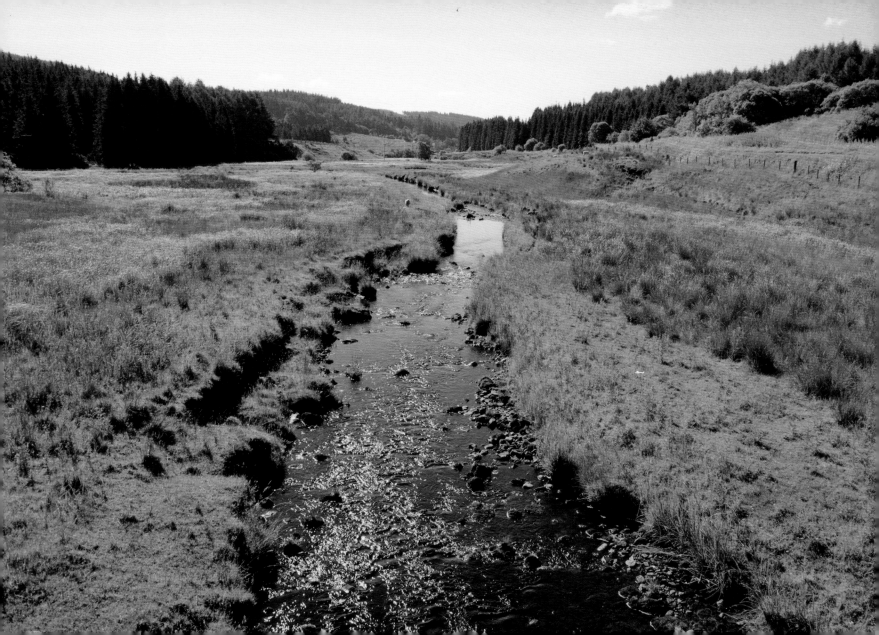

Kielder Village

The North Tyne is joined at Kielder village by the Kielder Burn, also known as the 'Violent Stream'. A burn is a North East England and Scottish term for a watercourse with a size between a stream and a small river.

The Duke of Northumberland had a castellated shooting box erected at Kielder so he could have a base from which his shooting parties could hunt grouse on his moors. The architect for the building was Newcastle upon Tyne based William Newton (1730–98). Known as Kielder Castle, it isn't as the name suggests a defensive building but simply a folly. Modified in 1926, the building is Grade II listed and is now used as a free entry visitor centre, small museum and café.

In 1932 the state obtained the Kielder Estate as payment in lieu of death duties arising from the death of the then Duke of Northumberland. The Forestry Commission were tasked with carrying out tests to establish if the estate could be used for the growth of timber. Following the First World War a decision had been taken to build up a national reserve of timber. The experiment was a success and as a result the Forestry Commission built a model village to house forestry workers and the largest man-made forest in Northern Europe was planted. Kielder Forest now covers 250 square miles and remains the largest working forest in England.

The United Reform Church was built as a Presbyterian chapel in 1874 by F. R. Wilson (1827–94), the Duke of Northumberland being the benefactor. The building is Grade II listed. Unfortunately, the church was locked during my visit so I was unable to see the inside.

Opposite: Kielder Castle.

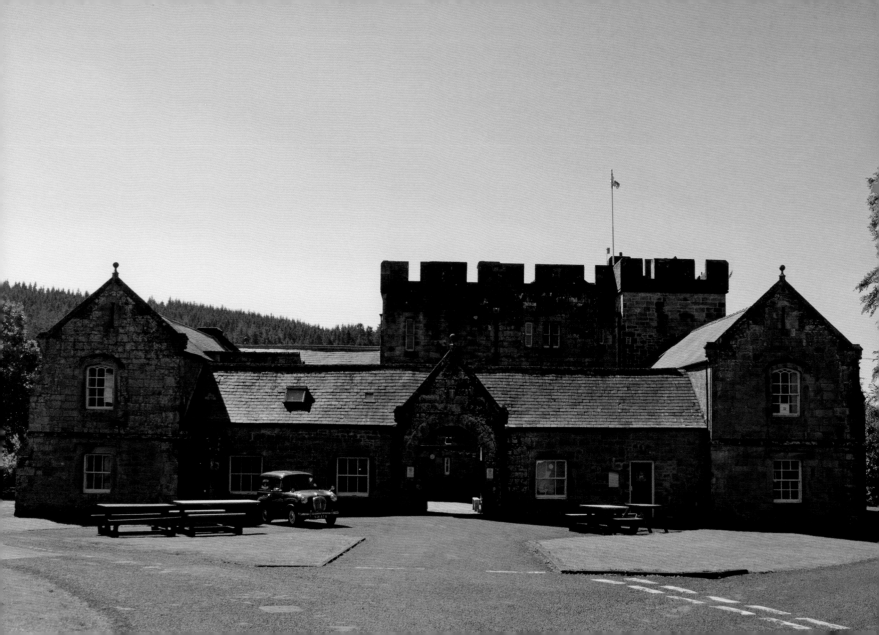

Kielder Viaduct

Crossing the North Tyne is this marvellous piece of engineering. It no longer carries rail traffic but instead is open for walkers and provides a marvellous viewpoint for both the river and Bakethin Reservoir. Opened in 1862 by the North British Railway, it was originally to a design by engineer Robert Nicholson (1808–55). Unfortunately, Nicholson died before completion and the task was taken over by his nephew John Furness Tons (1822–81). The building contractors for the project were William Hutchinson and John Ridley.

The viaduct presented an engineering challenge as the line of the railway required it to cross the North Tyne at an angle and to be parallel to the river to counter the force of the water current. Mathematician Peter Nicholson (1765–44) from Newcastle School of Design had been involved in calculating the loads required to build the viaduct. His work resulted in the seven arches being constructed at a skewed angle, each stone block being cut to individual shapes and laid in helical courses. The upper deck was constructed in a baronial style with a castellated parapet and false arrow slits in the voussoirs. It is thought that the style was meant to compliment Kielder Castle and was a compliment to the duke of Northumberland.

Passenger traffic ceased on 15 October 1956, with freight trains operating until 1 September 1958. The final train to pass over the viaduct was a Hawick–Newcastle excursion on 7 September 1958.

In 1969 the viaduct was threatened with demolition, but was rescued by the Northumberland and Newcastle Society who purchased it from the Forestry Commission. The viaduct is now a Scheduled Ancient Monument, being one of the finest surviving examples of a skew arch form construction in England.

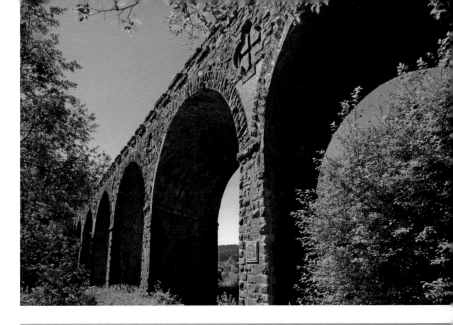

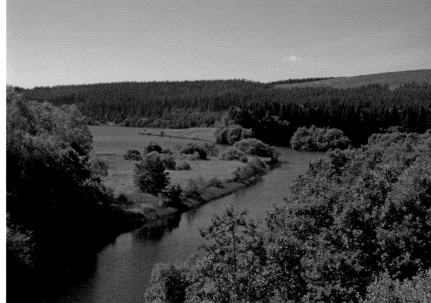

Above: Kielder Viaduct.

Below: Looking towards Bakethin Reservoir from the viaduct.

Kielder Water

Opened by Her Majesty the Queen on 26 May 1982, the reservoir was at the time the largest man-made lake in Northern Europe.

With a capacity of 44 billion gallons of water it has a shoreline measuring 27 miles (43 km) and a length of 7 miles (11 km) and at its deepest point it is 170 feet (52 m) deep. Costing £167 million, it was constructed by Northumbrian Water to provide a supply to the North East of England. In recent years, when drought conditions have depleted water sources in the rest of the United Kingdom, Kielder Reservoir has proved its worth. Water is provided to the rivers Tyne, Wear, Tees and Derwent to ensure water levels are maintained. To enable the transfer of water to the Wear and the Tees rivers, a pumping station was built further east at Riding Mill on the River Tyne. Water is drawn from the Tyne and pumped via a concrete lined tunnel to maintain water levels in the two other rivers.

The project took around four and a half years to complete, resulting in the relocation of twenty-six family homes as well as farms and a school when the valley was flooded.

Kielder Dam is equipped with two hydroelectric generators which produce 6 megawatts, sufficient to provide electricity to 1,100 homes.

Kielder Water is a tourist attraction with many sporting and educational activities taking place both on its waters and also on its shores. Sailing, canoeing, walking, and cycling being just some of the activities. Several visitor centres surround the lake as well as lodges and caravans, which are able to be hired for holidays.

Since 2008 the Kielder Observatory has allowed stargazers to view the night sky in excellent conditions, being so far from heavily populated and light polluted areas has meant the skies above Kielder are ideal. Now designated as an International Dark Sky Park it has been awarded Gold Tier status for the high quality and lack of light pollution of the starscape by the International Dark Sky Association. It is the largest Dark Sky Park area of protected night sky in Europe.

Opposite: Kielder Water looking south.

Falstone

Lying just to the south of the Kielder Dam is the small village of Falstone.

There are two meanings of the name 'Falstone'; from the Anglo-Saxon word *faeston*, or stronghold for securing livestock. In Old English its meaning is 'multi-coloured stone', which may have been a stone used a boundary or as a meeting place marker.

Until 1843 the village was only accessible by a ford across the North Tyne, but in that year a bridge was erected under the instruction of engineer Henry Welch (1795–58) and Inspector John Ridley. The bridge is Grade II listed.

For a small village it is surprising that it is served by two churches, St Peter's Anglican church and the former Presbyterian church, now a United Reformed church. St Peter's was built in 1824 to a design by Newcastle upon Tyne father and son architects John (1787–1852) and Benjamin Green (1811–58). Severely damaged by fire in 1891, it was remodelled by Plummer and Burrell. The churchyard contains many early seventeenth-century headstones including five which are Grade II listed. The current United Reformed church dates from 1807 but an earlier Presbyterian chapel had stood on the site from 1709. The church was extended in 1876 including the addition of a tower. It is Grade II listed.

Opposite: St Peter's church, Falstone.

Hesleyside Hall

The Grade II* listed Hesleyside Hall stands looking out on to the North Tyne and is the ancestral home of the Charlton family, now operating as a private country house which offers accommodation and a venue for weddings.

The Charltons had a pele tower on the site from the fourteenth century. Pele towers are small fortified keeps or tower houses, many of which were built along the English and Scottish borders. By an Act of Parliament in 1455, each of these towers was required to have an iron basket on its roof so that a smoke or fire signal could be sent to warn of invasion from Scotland.

A house and tower were then added in the sixteenth century, parts of which are still incorporated within the present day hall. One retained part of the earlier building is a priest's hole, which was a hiding place for priests built into many of the principal Catholic houses of England during the period when Catholics were persecuted by law in England. Some of the rebuilding was to a design by William Newton in the eighteenth century.

During 1776 the gardens were laid out by the famous landscape gardener Capability Brown (1716–83) and the original plans are retained at the hall.

Opposite: Hesleyside Hall, old postcard view.

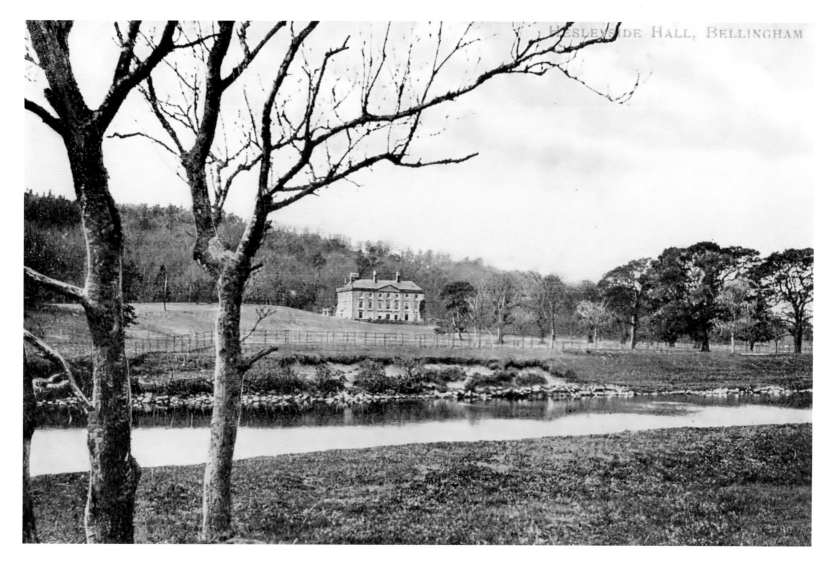

HESLEYSIDE HALL, BELLINGHAM

Bellingham

The first market town on the course of the North Tyne from its source, one thing which may confuse the visitor to Bellingham is the pronunciation of its name; it is pronounced 'Bell-in-jum'. The town takes its name from the De Bellingham family who owned lands in the area.

While this is a comparatively small town, it is a popular stopping point for tourists and also a staging point for those partaking in the Pennine Way National Trail. It also has numerous historical features that are worthy of note.

Bellingham Bridge

Prior to its opening in 1834, the town was accessed by a ford. Writing in 1760, Bishop Pococke (1704–65), who was well known for his travel writings, passed through Bellingham and wrote, 'there is not one bridge over the North Tyne, but they have a summer ford at the town and a winter ford a mile lower called Bridge Ford'.

The Grade II listed bridge was designed by the architect John Green and originally included a single-storey toll-house.

Opposite: Tyne Bridge, Bellingham, old postcard view.

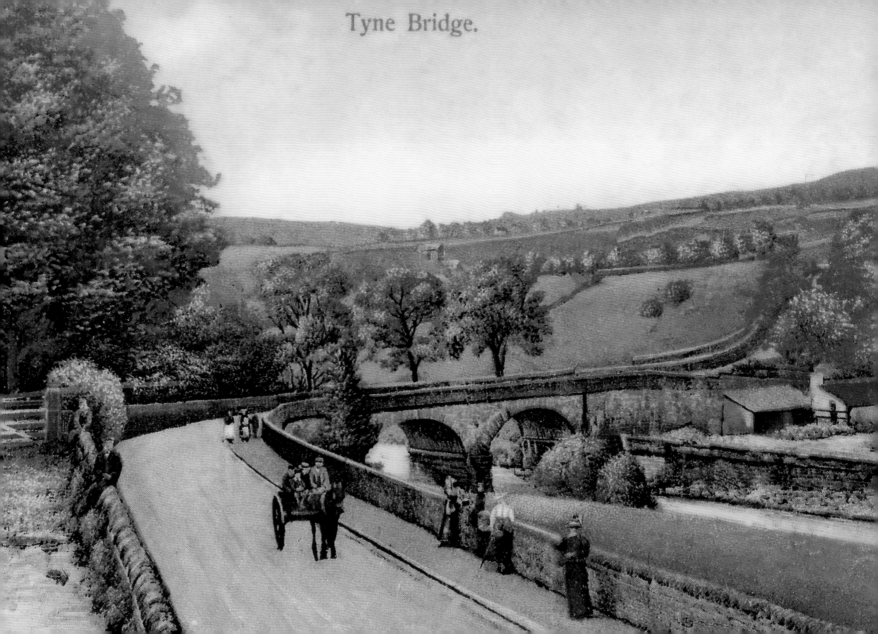

Tyne Bridge.

Church of St Cuthbert

Dating from the thirteenth century, the church of St Cuthbert is a Grade 1 listed building. The stone barrel vaulted nave roof is a remarkable feature and its roof is also notable as it is covered by strips of single and double thickness stone slabs running down the roof pitch. This covering is thought to date from the seventeenth century and was installed to prevent invaders setting the roof on fire.

The Long Pack

Within the churchyard is an unusual grave cover named The Long Pack, which carries an intriguing tale.

In 1723, a pedlar called at the home of Col Ridley at Lee Hall. Ridley and his family were in London at the time and the hall was under the supervision of three servants. The pedlar attempted to sell his wares to the housekeeper and also to request lodgings for the evening. The housekeeper refused to provide accommodation, but agreed that his long pack could be left for collection that next morning.

During the evening the long pack was observed to move and one of the servants picked up a gun and shot at it. On closer examination a mortally wounded man was found inside, together with a musket, sword and whistle. It is thought that this was an attempt to rob the hall, the man planning to signal his accomplices during the hours of darkness using the whistle. The name of the man in the long pack was never discovered.

Opposite: Inside of the church of St Cuthbert.

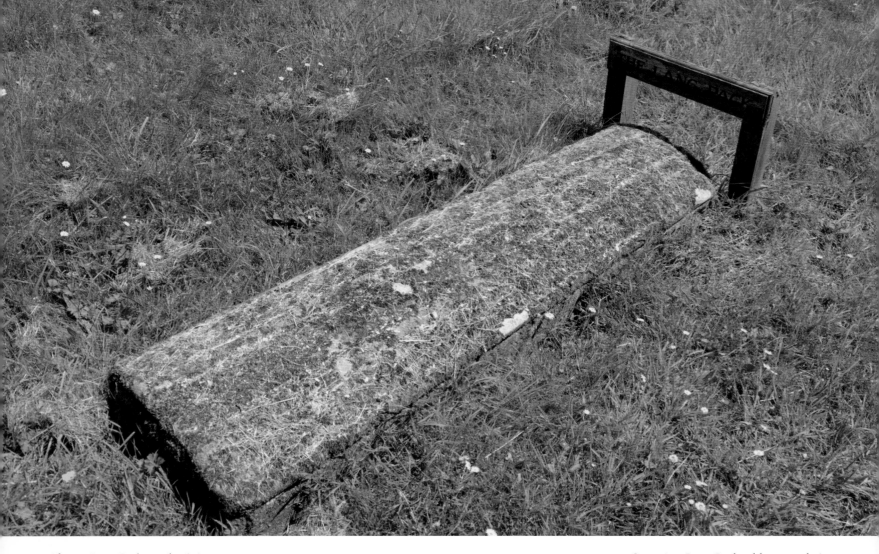

Above: Long Pack, modern view.

Opposite: Long Pack, old postcard view.

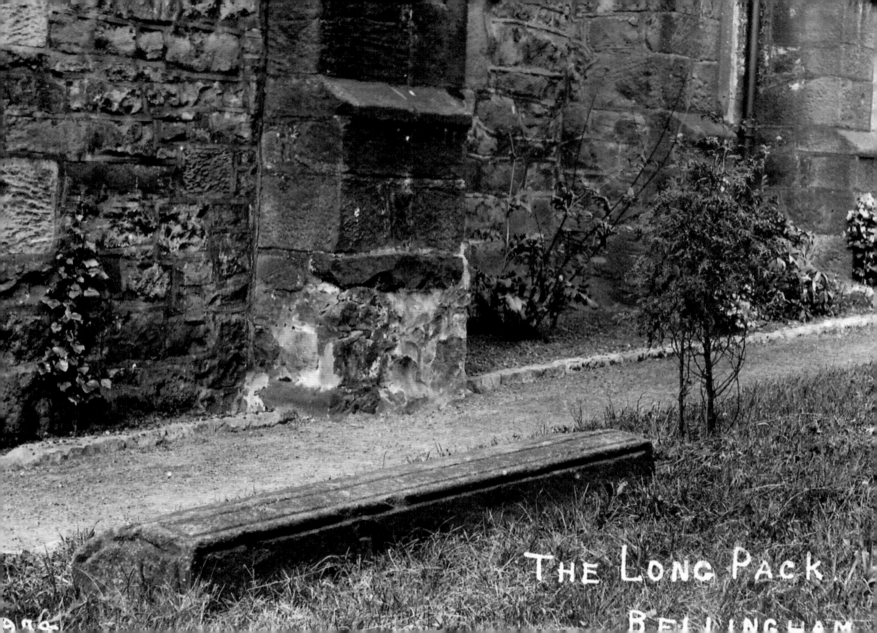

THE LONG PACK.
BELLINGHAM

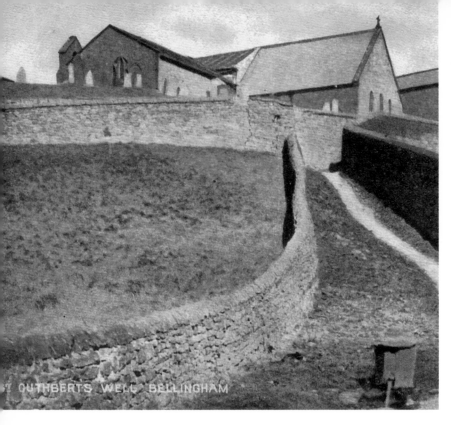

Above: St Cuthbert's Well, old postcard view.

Opposite: St Cuthbert's Well, modern view.

St Cuthbert's Well

Known locally as Cuddy's Well, it is located to the south of St Cuthbert's church and is thought to have miraculous properties. It is claimed the spring was discovered by St Cuthbert while dowsing and subsequently blessed. Its waters, which never dry up, are still used in the church of St Cuthbert for baptisms.

Reginald of Durham, writing in the middle of the twelfth century, reported a miracle which involved a young girl called Edda who, despite it being the Holy Day of St Lawrence, insisted on sewing a dress. As a consequence of this act, her left hand contracted in such a way that she couldn't release the cloth that she was working with. She was taken to St Cuthbert's Well where she drank the water and then spent the night within the church. At dawn she woke and witnessed a vision of St Cuthbert who touched her hand and she was unable to release the cloth. However, she screamed and caused the apparition to disappear and her hand again contracted. A Mass was then held and after the gathered congregation made a novena of nine paternosters for her recovery she regained the use of her hand.

The well was surrounded by a structure in the eighteenth century, known locally as a pant and the cover and is thought to be medieval in origin. The well is Grade II listed.

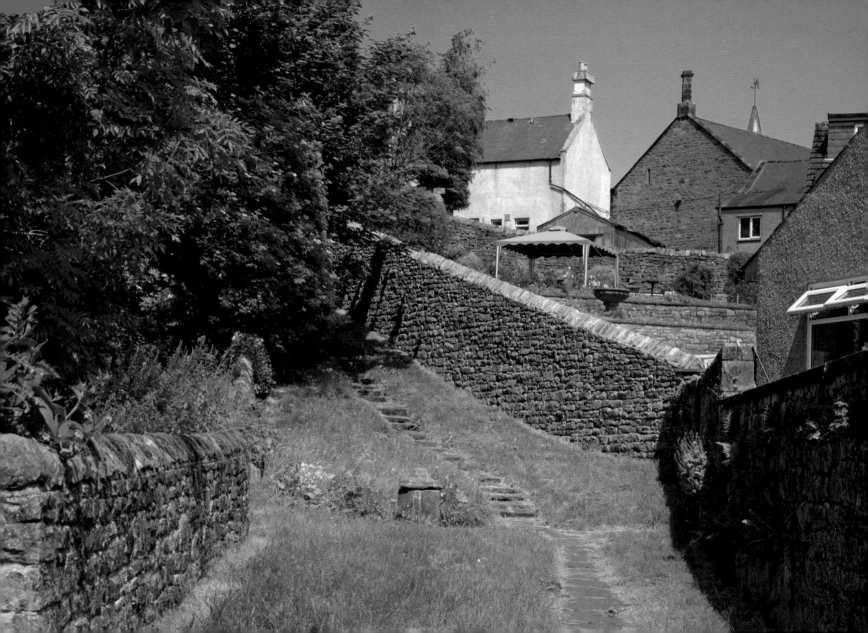

Boer War Memorial Fountain

A fine memorial to those from the town and area who took part in and returned from the Boer War (1899–1902) stands in Manchester Square, the figure being that of a fusilier in full South African campaign kit, complete with Lee Enfield rifle. It is rather unusual to find a memorial dedicated to the surviving rather than those killed in action.

The memorial had previously been located at the crossroads within the centre of the town, but was considered in later years to be a motoring hazard and was consequently moved in the 1950s to its present location.

Built in 1902, it also incorporated a drinking fountain which is no longer working. The memorial has Grade II listed protection.

Opposite: Boer War Memorial Fountain.

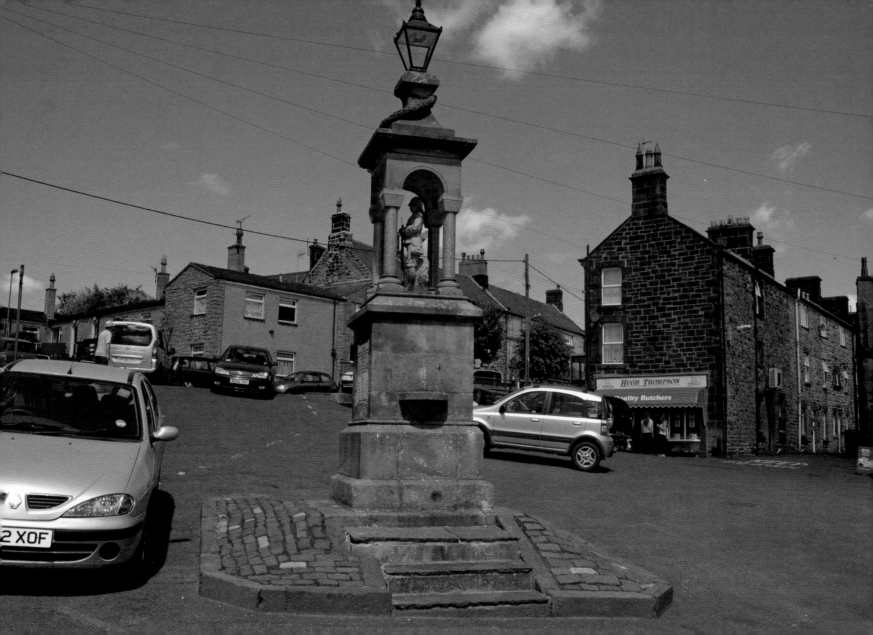

Wark on Tyne

There are two villages called Wark in Northumberland and to differentiate between them they are named as Wark on Tyne and Wark on Tweed.

Similarly to Bellingham, Wark is pronounced in a different way to which a visitor may assume, not being akin to how you would say 'walk'; in Northumberland it is 'ark' with a 'w' in front.

The name Wark is from the Old English for 'works or fortification'. It is believed that an earthwork motte-and-bailey castle was built to the immediate south of Wark at Motte Hill, close to a shallow part of the North Tyne which permitted a ford crossing.

The village is linked across the North Tyne by an iron bridge on seven stone piers, constructed by the Gateshead firm of Hawkes, Crayshay & Sons, which replaced an earlier toll bridge. To cope with modern-day traffic, the bridge now carries only a single track. At the time of my visit the bridge was under major repair. The bridge certainly affords picturesque views of the river which slowly passes Wark.

The village green is bordered by the imposing Grade II listed Mechanics' Institute building, which was erected in 1873 and it was good to see that the clock on the tower keeps the right time. Mechanics' institutes were set up to educate working men, mainly in technical subjects and funded by local industrialists in an effort to have a more knowledgeable workforce. Many institutes also provided libraries for the local adult population.

Also on the village green is the memorial cross to the fallen of both world wars, unveiled on 26 March 1921.

In 2003, Wark was selected to be the first village in Northumberland to trial the use of solar powered streetlights, this being the first project of its kind in the north-east of England.

Above left: Wark village green, old postcard view.

Above right: Wark village green, modern view.

Right: River North Tyne at Wark.

Chipchase Castle

The Anglo-Saxon village of Chipchase has long since been lost, but Chipchase Castle remains and lies on a plateau above the North Tyne. The name Chipchase is thought to be derived from the Old English word for 'cheap or market'.

A Grade I listed building and Scheduled Ancient Monument (SAM), the castle has been modified a lot over the centuries, but its earliest fabric consists of a mid-fourteenth-century pele tower, with later attached Jacobean mansion with Georgian and Victorian alterations.

The castle has had many owners over the years, but the earliest occupant of the pele tower is recorded as Sir Peter de Insula in the mid-thirteenth century. By the late seventeenth century, the Chipchase Estate had passed into the hands of the Heron family through marriage. By 1727 Chipchase was sold to George Allgood, a member of the Hexham merchant and lawyer family.

Things did not go well for Allgood, his relationship with tenants and neighbours on acquisition of the estate being soured, leading to a complaint to the clerk of the peace on 12 January 1728. The complaint was that due to his land rights being challenged he could not get a dish of wildfowl for himself or friends by reason of so many gunners and poachers. He complained that some of his neighbour's hounds ran day and night into his grounds, 'where they trample both the summer and winter corn miserably'.

The castle is now in private ownership but is open to the public during June each year.

Opposite: Chipchase Castle, old postcard view.

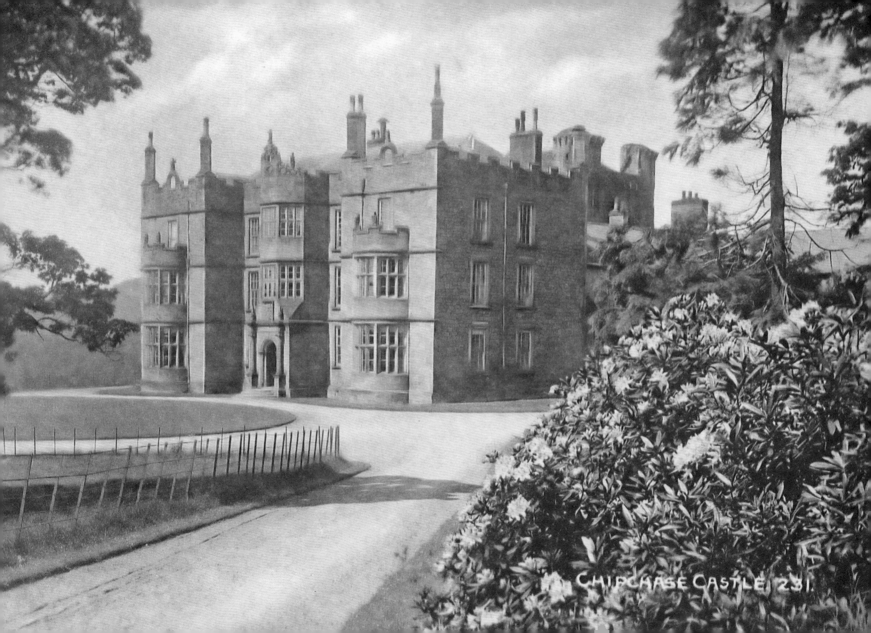

CHIPCHASE CASTLE. 231.

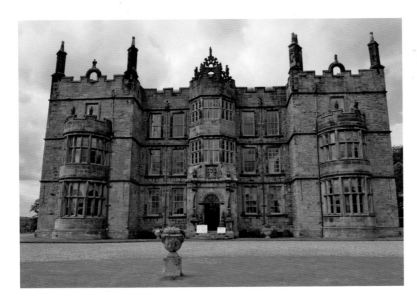

Above: Chipchase, modern view.

Opposite: The church of Saint Giles, stables and hearse house.

Chollerton

The small hamlet of Chollerton is worthy of mention for its fine church, church stables and hearse house.

The church of St Giles Chollerton is a Grade I listed building and the earliest fabric dates from *c.* 1260 when it is thought William de Swinburne, a Scottish knight, erected a stone place of worship. The stone-built church predates an earlier Anglo-Saxon church, but much of what is seen externally was restored and Gothicised in 1873. Internally the church contains Roman monolithic columns, which were originally sited at Corstopitum (the Corbridge Roman site), and a reused Roman altar.

The church stables and hearse house sit at the entrance to the churchyard and have Grade II listing protection. Dating from the early nineteenth century, they may well contain recycled medieval materials. The original horse mounting block is also worthy of mention.

Humshaugh

This village's name has a Northumbrian pronunciation, which no doubt confuses the visitor to this village as it does with aforementioned examples. It is pronounced as 'hums zoff' and is derived from the Old English for 'Hun's water meadow'.

Though a small village it has some interesting historical associations. Firstly, there is the paper mill, powered by the North Tyne, which was set up by Capt. William Smith in 1788. In 1793 the British government commissioned Smith to aid with its fight against Napoleon. The mill was commissioned to produce counterfeit French Assignats, which were the form of currency issued by the revolutionary government of France. The forged notes were taken to France by the Army and designed to devalue the French financial system. The Society of Antiquaries of Newcastle upon Tyne is the custodian of one of the remaining moulds used in the forging process. The mill operated until 1888 and parts of its fabric remain in the two Grade II listed cottages.

Another piece of Humshaugh history concerns itself with Lord Baden-Powell and the Scouting Movement. Having carried out an experimental camp at Brownsea Island in 1907, it was decided to hold the first official Scout camp from 22 August to 4 September 1908. The Humshaugh camp involved thirty invested Boy Scouts from around the United Kingdom.

Kevin Whately, the famous actor noted for playing Lewis, was brought up in Humshaugh having been born at Hexham Hospital on 6 February 1951.

Lying to the north of Humshaugh is the Grade 1 listed Haughton Castle, now a privately owned country mansion. It is tantalising hidden behind trees, leaving the top of the towers only visible to the hopeful photographer, as I found during my visit.

Originally built as a tower house in the thirteenth century, its transition to castle status continued in the fourteenth century when it was fortified and heightened. Falling into ruin during the sixteenth century, it was rescued in 1816 when restoration, including those under the guidance of Newcastle Architect John Dobson (1787–1865) and Durham's Anthony Salvin (1799–1881), resulted in the present day mansion.

The castle has been used as a location for a number of movies, including Catherine Cookson's *The Dwelling Place* and Enid Blyton's *Five Go to Smuggler's Top*.

Opposite: Haughton Castle, old postcard view.

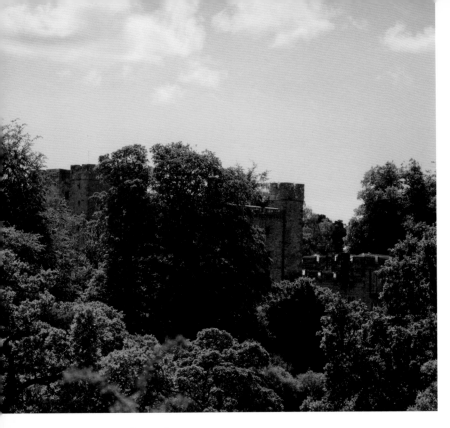

Haughton Castle, modern view.

Chollerford and Chesters Roman Fort

Chollerford is a hamlet at the crossing of the North Tyne of the Roman Road (B6318) and consists of The George Hotel, Chollerford Bridge, a car service garage and a few houses. In Old English the meaning of Chollerford is either 'Ceola's ford' or 'ford in a gorge'. However, it is more notable for the nearby Roman fort of Chesters.

The five arched stone-built bridge dates from 1785 and is to a design by Robert Mylne (1733–1811), it is Grade II listed. Spanning 90 metres, the 1785 bridge replaced an earlier stone built bridge which was swept away by the Great Flood in 1771. The destroyed medieval bridge was probably built prior to 1394 when Walter Skirlaw, Bishop of Durham granted 'thirteen days' release from enjoined penance' anyone who assisted with its restoration. The bridge is the most southerly crossing on the North Tyne.

A weir and fish pass are located just to the south of the bridge where salmon can be seen leaping in the spawning season.

The George Hotel sits beside the road bridge and while much extended was originally built as an Inn in the eighteenth century. As with many buildings in the era it is often suggested that the stones came from the nearby Hadrian's Wall.

To the south and within half a mile of Chollerford Bridge lies the Chesters Estate which contains the Roman fort of Cilurnum, now commonly named Chesters. The name Cilurnum has two meanings, 'cauldron pool' and is also thought to relate to the Cilurnigi people of northern Spain who formed a 500 strong Asturian cavalry unit which was based at Chesters for 200 years. Both suggestions are plausible, given the closeness to the North Tyne it could well be that there was an area of disturbance which appeared as a cauldron. It could of course be a mixture of both.

The route of Hadrian's Wall runs from Segedunum Fort in Wallsend in the east to Bowness on Solway to the west, a distance of 73 miles (117.5 kilometres). The wall passed through Chollerford and it was necessary to cross the North Tyne, this entailed the erection of a bridge, evidence of which can still be seen.

Having built a bridge it was necessary for a defensive fort to be built to offer protection, however this is not thought to have been erected until two years after the completion of the bridge and the section of wall. The fort was actively garrisoned with cavalry for at least 200 years before the Roman's withdrew from Britain.

Following the abandonment of Hadrian's Wall much of the visible stone courses were robbed and used in construction of other buildings, it is often said that most of the present farm houses on the course of the Wall are constructed from such re-cycled materials. Indeed there is reference to Saxon period builders sourcing stone for a church in nearby Hexham with stone removed from the Roman bridge in AD 675.

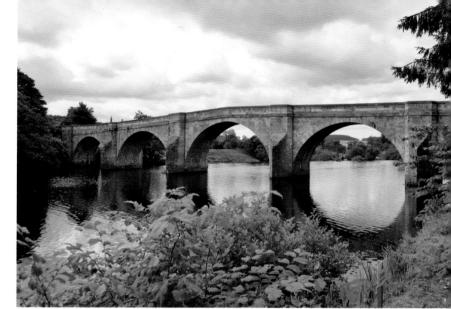

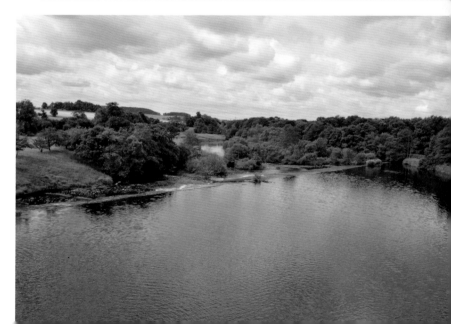

Above: Chollerford Bridge.

Below: River North Tyne at Chollerford, looking west towards the weir.

The site returned to agricultural use and lay untouched and undiscovered for a thousand years until the investigations of the Lawyer and Newcastle Town Clerk, John Clayton (1792–1890). Clayton's father, Nathaniel had purchased the Chesters Estate in 1796. John Clayton had an avid fascination in Roman antiquity, a member of the Newcastle Society of Antiquaries, and as a result carried out extensive archaeological investigations over more than fifty years at Chesters to once again bring the fort to light. He was also instrumental in the preservation of many other sites along the course of Hadrian's Wall.

Today the fort is under the custodianship of English Heritage and is open to the public containing a visitor shop, museum and extensive grounds containing the forts remains. The fort is well set out on fairly flat ground, falling slowly downhill towards the area closest to the North Tyne. The various buildings such as the Headquarters, Commanding Officer's House, Barracks and baths are well set out with information boards; however the purchase of a guide book at the entrance shop is well recommended.

The remains of the Roman bridge are best viewed on the opposite side of the North Tyne from the fort and thus are not accessible from Chesters. To visit the remains it is advisable to approach on foot, a short walk from the present road bridge located to the north. However pleasant views of the North Tyne can be achieved from Chesters fort much as would have been seen by the Romans on their arrival to Britain.

Close by the entrance to the fort site is the Grade II Listed museum building which houses a multitude of Roman artefacts discovered during excavations at Chesters and beyond. Designed by Scotsman, Richard Norman Shaw (1831–1912), noted as an architect of country houses and commercial buildings. The museum was opened in 1903 and its exhibit cabinets and design are much in keeping with their nineteenth-century roots. Entry to the museum is included with the fee to the fort.

The Chesters Estate was held by the Errington Family since at least 1555 and the present country mansion was designed in 1771 by York architect John Carr (1723–1807) for John Errington of Walwick Grange. Additions were made to the mansion by Newcastle architect John Dobson in 1832–37.

The estate was purchased by Nathaniel Clayton in 1796. The mansion was greatly extended by R. N. Shaw in 1891. Shaw also designed the fine stables at Chesters, which stand on the opposite side of the Military Road (B6318) from the main estate. The modified baroque style of the stables building is often compared to those employed by Sir John Vanburgh (1664–1726).

Both mansion and stables are now Grade II* listed, privately owned and not open to the public.

Opposite: Chesters Roman fort, old postcard view.

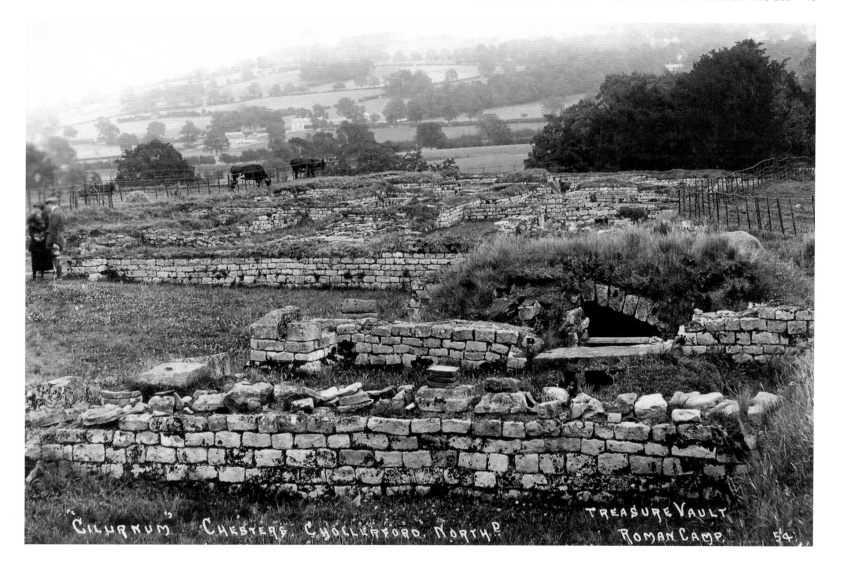

"CILURNUM" CHESTERS CHOLLERFORD NORTH⁰ TREASURE VAULT ROMAN CAMP. 54.

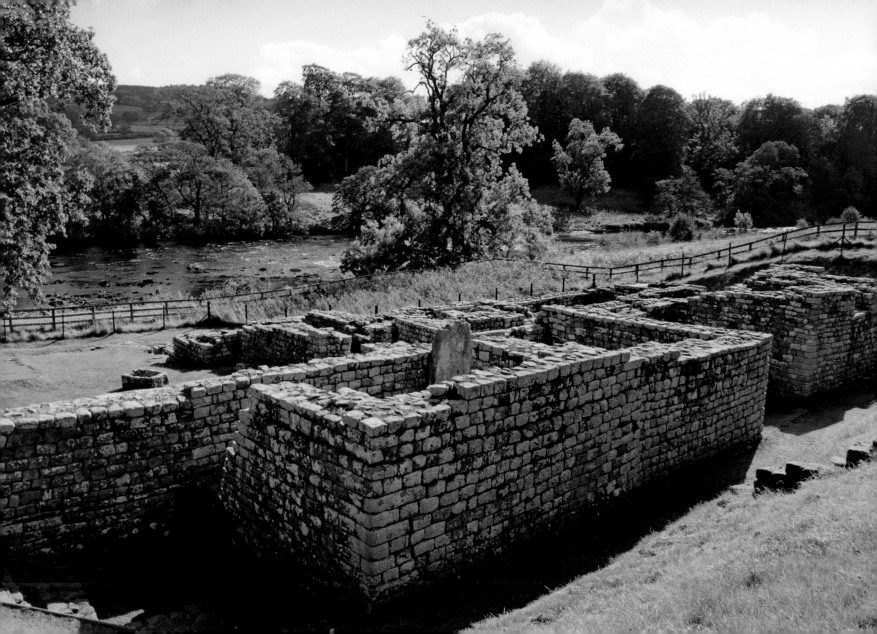

2

THE SOUTH TYNE – TYNEHEAD TO WARDEN ROCK

Source of the South Tyne

In marked contrast to the source of the North Tyne, the South Tyne rises high up on the fells of the North Pennines of Cumbria and quickly flows downhill in its journey to join with the North Tyne at Acomb.

The source rises on the desolate but beautiful Cross Fell and is 1,950 feet (593 metres) above sea level. Located within 2 miles (3.2 kilometres) of the sources of the rivers Wear and the Tees, it is interesting that three rivers should be born within such a short distance of each other, their watercourses ultimately running towards and into the North Sea. Cross Fell itself reaches the height of 2,930 feet (893 metres) and is also known as 'Fiend's Fell'; a myth exists that the moor is the haunt of evil spirits. On a clear day the counties of Cumbria, Durham, Yorkshire and Northumberland can be sighted as well as views into southern Scotland on the Solway coast.

The easiest way to reach the source is to travel from Alston south to Garrigill. Passing through the village of Garrigill, the road is signposted towards Tynehead. After around 2 miles (3 kilometres) the tarmacked road ends and reaches a cattle grid just past Hill House Farm. Vehicles must be left at this point; there is a small parking area at the side of the roadway

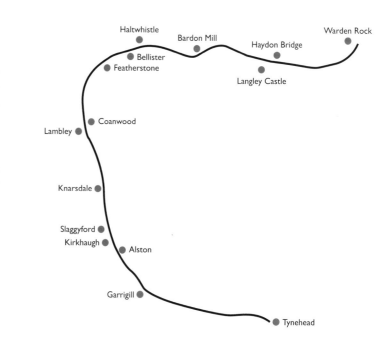

Above: Map of River South Tyne (not to scale).

Opposite: Chesters Roman fort, overlooking the River North Tyne.

and the remaining 2 miles (3 kilometres) need to be undertaken by foot. The track way from this point is hard packed and makes a comfortable walk to the source. It is part of the 23-mile-long South Tyne Trail, which travels to Haltwhistle in Northumberland, using footpaths, bridleways and the valley's old railway track bed

The source is marked, as is the North Tyne, with a tall sculpture by Gilbert Ward. It is said that looking through the space in the centre of the artwork allows the source spring to be seen. The sculpture uses stone from the nearby Flinty Fell.

The North Tyne at this point runs swiftly down through boulder-strewn gullies and on first look this appears to be a natural course. However, in the past the area was heavily mined for silver and lead. Indeed, there is evidence that the extraction has existed since pre-Roman times. One of the ways to mine the minerals was to dam the flow, then release the water which created a wave of water; the torrent of this wave would then propel boulders and stones to strip away soil and hopefully reveal veins of lead or silver. It is probable that this was a technique introduced to the area by the occupying Romans.

Garrigill

The first village on the course of the South Tyne, Garrigill is thought to be named after a Saxon Chief, Gerard, who brought his tribe over the Pennines from the Eden Valley. It is thought that 'Garri' is derived from 'Gerard' and 'gill', which comes from the Norse for steep-sided valley.

In the nineteenth century Garrigill was a thriving mining village with 1,000 workers working for the London Lead Co., extracting and processing lead ore. Writing in his book *The Tyne and its Tributaries*, William James Palmer paid a visit to Garrigill in 1875 and observed the way in which the local miners worked. Mining took place out on the moors and saw workers from Garrigill travelling out to the mines where they lived for the week, arriving on Monday and travelling back to the village on Fridays. They were housed at the mines in a 'miner's shop', which was a basic stone built hut that housed six to eight men and boys. Palmer makes the observation, having seen many of the passing miners, that each man carried 'a bag of spotless white over his shoulder; in most cases he was wearing a smock equally clean'.

William James Palmer also mentioned a story of the local miners poaching on the moors. By 1819, the crime of poaching had reached epidemic proportions, so much so that local law enforcement was proving fruitless. As a result, the authorities brought in the military, a party of 18th Hussars, stationed in Newcastle upon Tyne in an attempt to stop the offences. However, the poachers knew the moors and as a consequence led the soldiers on a 'wild goose chase' among the fells. After a long stay, the Hussars were unable to make one arrest and it was said that while the soldiers were good enough to fight the French they were no match for the men of Garrigill.

Garrigill is a pretty village with a population these days of around 200 people. Most of the buildings date from the eighteenth and nineteenth centuries, although there are examples of seventeenth-century construction. The first road bridge crossing the South Tyne is at Garrigill, and the village sits on two major modern-day trails – the Pennine Way and the Sea to Sea Cycle Route (C2C). Perhaps a sign of

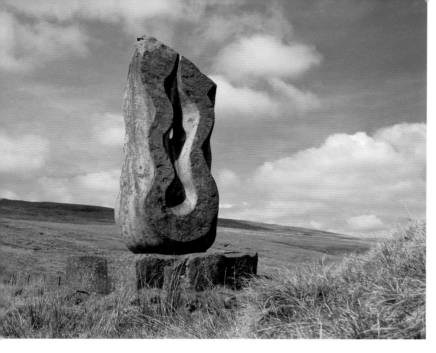

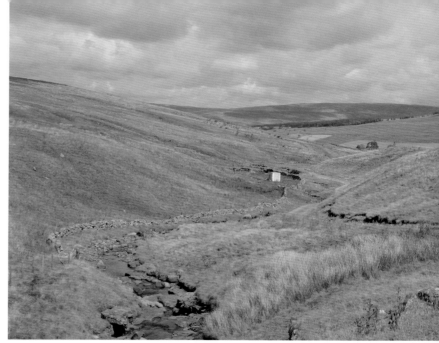

Above left: Source of the River South Tyne sculpture (by kind permission of Mick Quinn).

Above right: View looking north at Tynehead.

Right: Course of the River North Tyne at Tynehead.

current times is that the village pub, the George and Dragon, is closed and boarded up. The post office and general stores have survived though.

The parish church of St John stands on the road leading to Tynehead and was built in 1790 on the site of a medieval chapel. It was restored in 1890 with funding from the London Lead Co. Additionally, three Methodist chapels were present in the Garrigill area.

North Tyne Valley towards Garrigill.

Alston

Lying at the confluence of the rivers South Tyne and Nent is the isolated Cumbrian town of Alston. At one time the town was described as the highest market town in England, at 1,000 feet (300 metres) above sea level. However, while retaining its market square and cross it no longer holds weekly markets.

Originally named Aldenby, it was first recorded in 1164 and changed to Aldeneston in 1209. The name is thought to be derived from the Viking for 'settlement belonging to Halfdan'.

There is evidence of Roman occupation at the nearby Whitley Castle (Epiacum Roman Fort), which was built to protect the Maiden Way which passes on its way from Appleby in the south to Hadrian's Wall in the north. The fort, which lies 1 mile (1.6 kilometres) north of Alston, also acted as a protector to the numerous lead and silver mines which the Romans controlled on Alston Moor.

Alston is founded on the extraction sites of a number of differing minerals from the surrounding moors (lead, silver, coal and anthracite), though all the mines are now closed. The name 'Silver Mines of Carlisle' was given to the area in the thirteenth century when silver was mined and used with lead to manufacture coinage at the royal mint in Carlisle. It is recorded that in 1718 there were 119 mines operating in the Alston area. However, by the middle of the nineteenth century mining was starting to die out.

As with Garrigill, the major mine owners were the London Lead Co., whose altruistic concern for human welfare and advancement brought much advancement to Alston in the form of public buildings such as a school, market hall and sanitary house.

Alston is a town that gives the visitor a feeling of stepping back into the past. When walking up the cobbled stone Front Street, one passes seventeenth-century buildings, which certainly creates the impression of being in a different world.

When walking up Front Street from the bottom of the hill you will pass, on the right-hand side, the Grade II listed Gothic style town hall, which dates from 1857 and was designed by A. B. Higham. Built as municipal offices, it has been used to house a library and Trustee Savings Bank over the years, both the latter have subsequently relocated. It is now the home of the Alston Tourist Information Centre.

Passing Church Gates Cottage on the left-hand side, dating from 1681 we come to the parish church of St Augustine of Canterbury. The first record of a church in Alston dates from 1154 when King Henry II appointed a rector named Galfrid, but it is considered that a church has been on the site since before the twelfth century. In 1869, it was decided to demolish the previous church of 1770, which had been designed by John Smeaton (1724–92) of Eddystone Lighthouse fame. The present church was designed by J. W. Walton with the spire, designed by G. D. Oliver, added in 1886. One feature of the church that has no religious significance is the Derwent water clock, which is located close to the entrance door. Gifted to the church in 1767, it was originally part of Dilston Castle in Northumberland and dates from at least the seventeenth century. A single handed clock, it was restored to working order in 1977.

Further up from the church is the market cross, a Grade II* listed building. As aforementioned, no weekly market now takes place in the town. Originally erected in 1764, it was rebuilt in 1883. Standing as it does on a bend in Front Street, it has not stood up well to modern day motorised traffic and has been knocked down by wagons in 1968 and 1980. A foundation stone on the original market cross had the following inscription: 'This Market Cross was erected by The Right Honourable Sir William Stephenson, born at Crosslands in this Parish and elected Lord Mayor of London 1764.' The plaque is now in the church.

Garrigill village green.

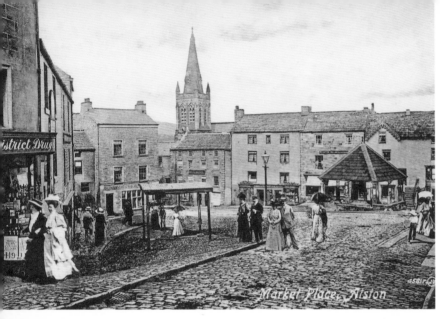

Alston was linked by rail in 1852 but the line to Haltwhistle in Northumberland was threatened with closure as part of the Beeching Report in 1962. Owing to the town's isolation the vital passenger link was closure was initially rejected by the Government. However with improvements to road links in the 1970s the line was finally closed on 1 May 1976. That was not the end of the story as following closure of the line, The South Tynedale Railway Preservation Society was formed, taking over Alston railway station, they also acquired a three mile stretch of the line to Lintley Halt and operate The South Tyne Railway. This is a narrow gauge railway and is open to the public on a seasonal basis. The aspiration is for the line to be completely opened between Alston and Haltwhistle, the track bed still being in situ, much of it currently being used as the South Tyne Trail. Geographically the line of the original railway closely followed the course of the South Tyne Valley and good views of the river can be seen from the present day South Tyne Railway.

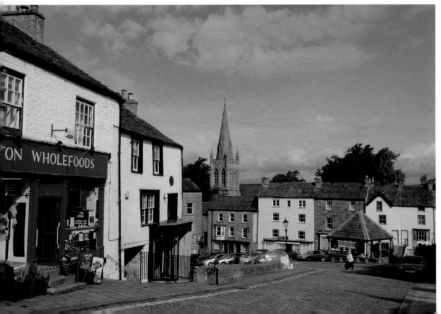

Above: Alston market cross, old postcard view.

Below: Alston market cross, modern view.

Opposite: Alston station.

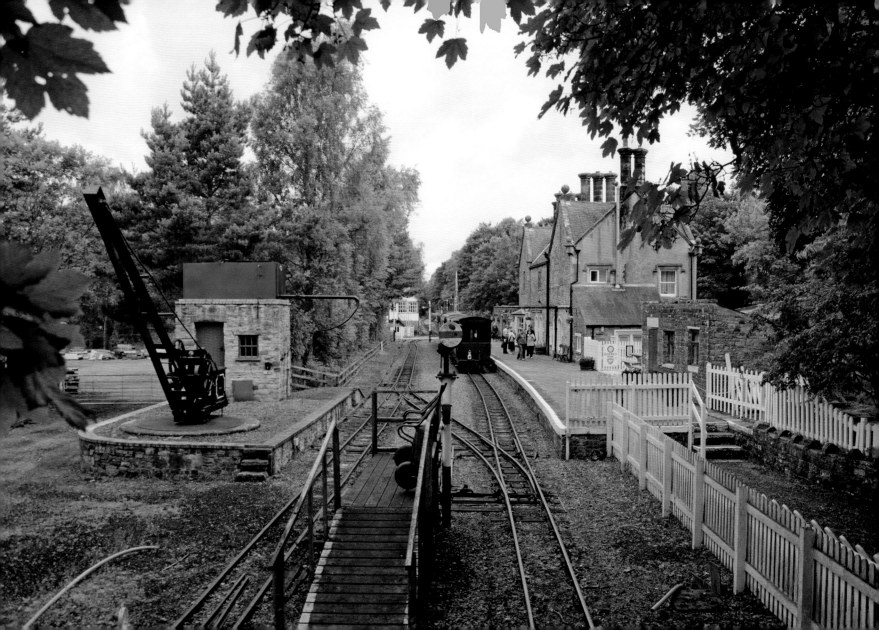

River North Tyne at Alston.

Kirkhaugh

Travelling out of Alston on the A689 road after 3 miles (5 kilometres), you come to the first village in the county of Northumberland, Kirkhaugh. The name Kirkhaugh is Old English, meaning 'water meadow with a church'; kirk is the name for a church, still used in Scotland and the Borders, haugh being an alluvial riverside meadow.

The area around Kirkhaugh has an ancient history, with occupation dating back to the Bronze Age. Indeed, during an official archaeological excavation of a burial mound, schoolboys from Alston discovered a 4,300-year-old gold ornament which

was worn as a hair tress. Tresses are very rare, only ten having been found in Britain.

The village is served by the church of Holy Paraclete, which is reached via a footbridge crossing the River South Tyne. Kirkhaugh and the church are on either sides of the river. The present-day church was built around 1869 and replaced a thirteenth-century building. It is notable that the present church was not designed by an architect, instead having been built to a design by the incumbent vicar, the Revd Octavius James, who took his ideas from a tour of churches in the Black Forest, Germany. The church is Grade II listed and contains two small stained-glass windows from the earlier thirteenth-century building. The church is notable for its flèche spire. Pevsner describes it as 'an absurdly thin needle-spire'. In the churchyard stands a Saxon hammerhead cross.

Slaggyford

The unusually named Slaggyford is the next village heading north on the A689 road and is derived from the Old English for 'muddy, dirty ford'.

At one time Slaggyford was larger in residential terms than nearby Alston, having its own market square. However, with the increase in lead mining around Alston many residents left to become miners and the population and village declined.

Slaggyford itself has no mineral seams of worth, but W. W. Tomlinson, in his *Comprehensive Guide to the County of Northumberland*, wrote that a grocer from Alston had dreamt on several occasions that he would make his fortune by discovering lead at Slaggyford. He sank a shaft at considerable

expense and commenced the excavations, but failed to discover any mineral deposits.

At one time the village had its own railway station on the Alston–Haltwhistle line, but this closed in 1976. The stationmaster's house is now in private ownership and the original wooden station buildings are still in place and may in the future feature as part of the narrow gauged South Tyne Railway.

One building of interest is the former Methodist chapel and Sunday school, now converted into holiday accommodation and named Yew Tree Chapel and the Old Sunday School.

Knarsdale

Further up the South Tyne Valley is the village of Knarsdale, which sits on the Knarr Burn which feeds into the River South Tyne. The name is taken from the Middle English, 'valley by Knarr'; in Old English Knarr means a 'rugged rock'.

Overlooking the valley is the church of St Jude. The current building dates from 1833, with a chancel being added in 1892 and the vestry being annexed in 1906. A church has been on the site since at least the seventeenth century, if not earlier, which is supported by the medieval cross slabs incorporated into the north wall.

The churchyard contains one notable headstone, that of Robert Baxter who died on 4 October 1796. The headstone

Above: Church of Holy Paraclete, Kirkhaugh.

Below: Slaggyford, former Methodist chapel and Sunday school.

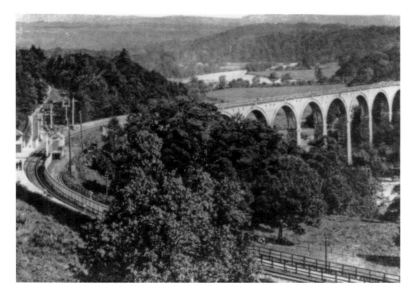

Above: Lambley Viaduct, old postcard view.

Opposite: Church of St Jude, Knarsdale.

contains this epitaph, which John Hodgson (1779–1845), the English clergyman and antiquarian, described as 'disgraceful doggerel'. The meaning of doggerel is a crudely or irregularly fashioned verse, often of a humorous or burlesque nature.

> All you who please these lines to read
> It will cause a tender heart to bleed:
> I murdered was upon the fell,
> And by a man I knew full well;
> My bread and butter which he'd lade,
> I, being harmless, was betrayed.
> I hope he will rewarded be,
> That laid the poison here for me.

The story is that Robert Baxter had an argument that led to the other party leaving a poisoned sandwich for him. The murderer was never identified.

Lambley

The name Lambley is from the Old English for 'clearing for grazing lambs', and its main feature is the former railway viaduct which crosses the River South Tyne.

Lambley Viaduct is part of the South Tyne Trail, open to the public, and is a pleasant walk of 2 miles (3 kilometres) from the dedicated car park at Coanwood. Adjacent to the viaduct is a wooden footbridge linking Lambley with Coanwood, which is a good vantage point for viewing the structure from river level. As part of the walk from Coanwood, you have to use the footbridge to cross the river and climb a set of stairs up to the viaduct deck. This is unfortunately due to Lambley station being closed off to the public. Originally, a footbridge was attached to the piers of the viaduct, but this fell into disrepair in the 1950s and was removed, being replaced with the present bridge.

The viaduct is Grade II* listed and was built in 1852 to carry the Alston–Haltwhistle railway across the South Tyne, the design being attributable to the Newcastle upon Tyne-born civil engineer Sir George Barclay Bruce (1821–1908). The span crossing the river is composed of nine arches, measuring 17 metres (56 feet), the total length of the viaduct being around 853 feet (260 metres).

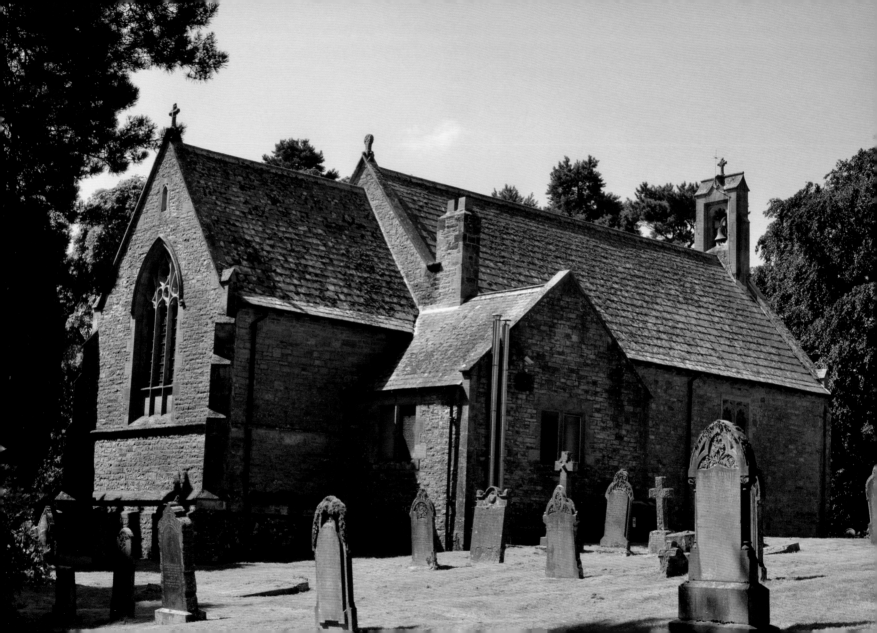

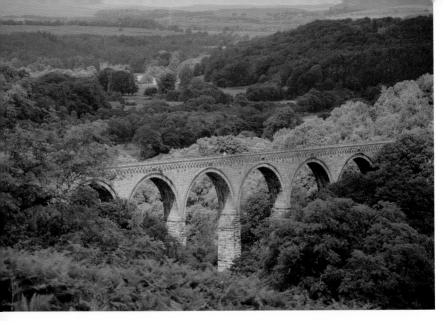

The height of the railway bed is 108 feet (33 metres) above the river. Writing in his book *The Tyne and its tributaries*, William James Palmer makes the observation that this is within a few feet of the height of the High Level Bridge at Newcastle upon Tyne.

The viaduct fell into disuse in 1976 when the railway line was closed and unfortunately it was allowed to fall into a state of disrepair. However, in 1991 it was decided that the now defunct North Pennine Heritage Trust would take over the custodianship (now with The South Tynedale Railway Preservation Society) with part of the deal being that the British Rail Property Board would make repairs. These were undertaken between 1995 and 1996. Part of the restoration involved the entire viaduct being repointed with lime; this entailed over 9,845 square feet (3,000 square metres) of lime imported from France being used.

As mentioned above, the southern end of the viaduct is closed off to the public at Lambley Station which is now a private house, unfortunate but it is understandable.

A Benedictine nunnery was located at the confluence of the Black Burn and River South Tyne at Lambley, having been founded in the twelfth century by Adam de Tindale and Heloise, his wife. Dedicated to St Mary and St Patrick, the nunnery was attacked and destroyed by the Scottish army led by William Wallace in 1296 and restored by William Tynedale in 1508. Following the Dissolution of the Monasteries in the late 1530s,

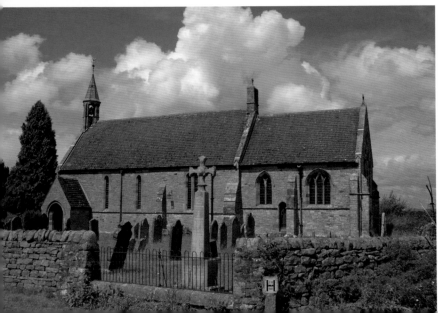

Above: Lambley Viaduct, modern view.

Below: Lambley, St Mary and St Patrick, external view.

Opposite: Lambley, St Mary and St Patrick, internal view.

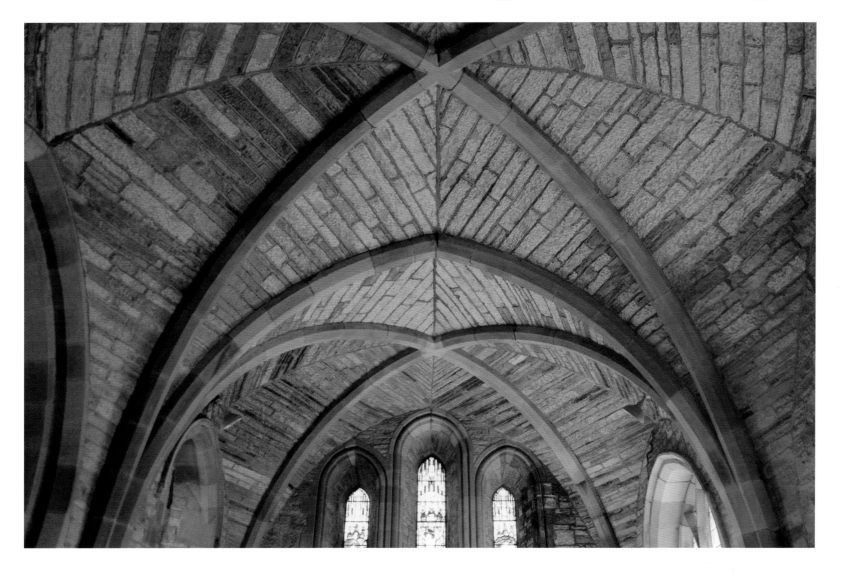

the nunnery fell into decay and eventually it was eroded by the flooded South Tyne in 1769, which led to its destruction.

The village is served by the Grade II listed church of St Patrick, named after the former nunnery. The present church replaced an earlier building and was designed by Scottish architect William Searle Hicks (1849–1902) and opened in 1885. The chancel has fine stone vaulting and it is claimed that the church bell originated at the nunnery of St Mary and St Patrick. The Lambley and Hartleyburn War Memorial is in the form of a cross of St Cuthbert and is made from Aberdeen granite. It is located in the churchyard, dedicated to the four local men who lost their lives in the First World War.

Coanwood

On the opposite side of the South Tyne Valley to Lambley is the village of Coanwood, which was anciently named Collingwood. The name is from the Old English 'Collan's wood', Collan being the medieval provost of Hexhamshire.

The main industry in the area was connected with the mining of coal, although there are no mining activities these days. The Coanwood Coal Co. was a major employer between 1860 and 1930.

One building of note is the Grade II* listed Coanwood Friends Meeting House, which dates from 1760. The building was erected by Cuthbert Wigham, a local landowner who had joined the Society of Friends, or Quakers, in 1734. The graveyard contains several headstones of the Wigham family, but this does not represent the number of Quakers buried there, due to tradition being they were buried without grave markers.

Headstones were prohibited up until 1850 when it was decided that plain markers of a uniform size and design could be used.

The Quaker congregation relocated from the building in 1960 and it was taken over by the Historic Chapels Trust in 1996. The Historic Chapels Trust rescues places of worship in England which are no longer used for religious practice with an aim to preserving the buildings for future generations. Many of the original internal features of the building, such as the flagstone floor and wooden benches, have been retained. While having no congregation, the Hexham Quakers hold a meeting at Coanwood every September for worship and a family picnic.

Coanwood was served by a railway station on the Alston–Haltwhistle line, closed in 1976, and both the station house and platforms survive. The railway in addition to passenger traffic provided a route for the transport of coal from the colliery.

Featherstone Castle

Located on a plateau at the base of the South Tyne Valley, the river passes by the castle at Featherstone, which lies in a splendid position. A public right of way starts at the modern road bridge crossing the River South Tyne on the Coanwood to Lambley road. That path follows the eastern side of the river, passing the former Second World War prisoner of war camp and ending opposite the castle. My interest in this site had been raised when I spotted some interesting shapes on the ground when using Google Earth. The satellite view of the former camp shows the outlines of the buildings and emphasises the extent of the footprint.

The origins of the name Featherstone appear to be the subject of debate, but all theories seem to suggest that it is derived from

monolithic stones that stood on a hill overlooking the present castle. Some theorise that a megalithic structure, comprising four upright stones, gave the name 'four stones' which in Old English translates to *feotherstan*. Another view is that that the name comes from 'feuder stones', which were two monoliths that acted as a central point where local inhabitants could meet with the lord of the manor to discuss grievances. There is also a suggestion that in the area of the stones was the original defensive tower which, due to decay, was rebuilt on the lower land in the position of the present castle.

The castle stands close to the confluence of the Hartley Burn and the River South Tyne and is Grade I listed. It was built in 1212 as a defensive manor house and pele tower for Helias de Featherstonehaugh. The earliest part of that building to survive is a thirteenth-century hall house, now incorporated in the west range and the south-west tower dating from the fourteenth century. However, much of the castellated style was added in the nineteenth century. In 1776, William Hutchinson (1732–1814), the English lawyer, antiquary and topographer, wrote of Featherstone castle as 'little more than a square tower, calculated for defence against those tribes of robbers, the moss-troopers'. The moss-troopers were bands of criminals who raided Northumberland from Scotland.

The castle became Hillbrow School, a boy's preparatory school, in 1950. The school remained there until 1961 when it was converted into a conference and activity centre for students.

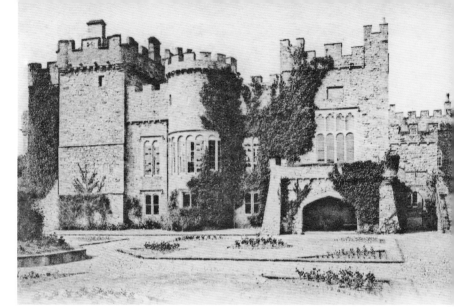

Above: Featherstone Castle, old postcard view.

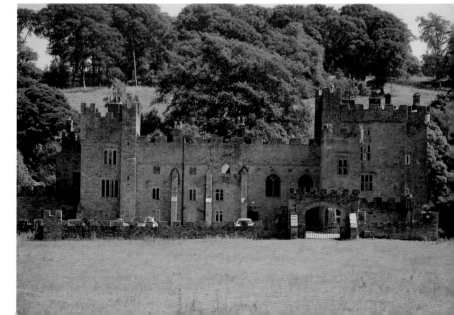

Below: Featherstone Castle, modern view.

Featherstone Prisoner of War Camp – Camp 18.

The castle is not open to the public but, as mentioned above, good views can be achieved from the pathway at the riverside.

As with most castles there is a ghost story attached to Featherstone. The Lord of the Manor, Baron Featherstonehaugh, arranged for his only daughter, Abigail, to marry a relative of his choice, even though the daughter was in love with a man from the local Ridley family. The wedding party left for the traditional hunt after the wedding, leaving the father behind to make arrangements for the banquet. When the party failed to return by midnight, the father began to fear the worst. Sitting alone at the table, he heard horses crossing the drawbridge. The door opened and the party entered but they made no sound and passed straight through solid objects. It turned out that the wedding party had been ambushed and all were killed, perhaps, it is suggested, by Abigail's spurned lover and his friends. It is claimed that on the anniversary of the wedding, the party can still be seen making their way towards the castle.

Featherstone Bridge crosses the River South Tyne at this point. Constructed in 1775, it is Grade II* listed and carries only one road track. Constructed as a single arched sandstone bridge, the span is 25 metres (85 feet).

In the Second World War an area to the south of Featherstone Castle was used to construct a training camp, named Camp 18, for troops from the USA. Erected in 1944, the camp housed troops prior to their deployment in the Normandy invasions. Despite it lying in the beautiful South Tyne Valley and beside the River South Tyne, the soldiers considered the camp to be too isolated and nicknamed it 'Death Valley'.

Following the departure of the US military personnel, the camp was then used for a short time to house Italian prisoners of war.

In 1945, the camp was converted to hold captured German officers. Rather than 'normal' prisoners of war, they were categorised as 'Black Nazis' who were fervent followers of Hitler's doctrines. It was considered that such prisoners could only be repatriated after the end of hostilities after extensive physiological rehabilitation and they received this at Camp 18.

The camp's footprint can still be seen, the foundation of buildings still visible as well as some that are still standing and during my visit were being used to house livestock. The camp originally had 200 huts, based in four sections and housing around 4,000 officers together with 600 orderlies from the lower ranks. The camp had a chapel, bakery, library, theatre and hospital. In the period 1945–48 there were 25,000 German

prisoners of war passing through the camp. The highest-ranking officer was General Ferdinand Heim, Chief of Staff to the Sixth Army, who was captured in Boulogne, France, in 1944.

Camp 18 closed in 1948 and at the entrance to the castle a plaque commemorates its existence with this epitaph:

> Here was the entrance to POW Camp 18 where thousands of German officers were held in the years 1945–48. The interpreter since January 1946 was Captain Herbert Sulzbach O.B.E. who dedicated himself to making this camp a seed bed of British German reconciliation.
>
> Our two nations owe him a heartfelt thanks. The friends and members of the Featherstone Park Association of Former Inmates of Camp 18, 1982.

One strange occurrence in fields adjacent to Featherstone Castle happened in 1825 when labourers were digging drains and discovered eight strange coffins. The coffins were formed from the trunk of oak trees, the centres having been hollowed out to hold the body of the deceased person.

Bellister Castle

To the north of Featherstone is the Grade I listed Bellister Castle, located on the eastern side of the River South Tyne. Bellister takes its name from the Norman French *bel-estre*, meaning 'fine place'. Unfortunately, the castle is not open to the public but it can be viewed from the nearby road, Bellister Bank.

The castle is actually a ruined tower house dating from the thirteenth century, with an additional house attached in the seventeenth century and is a Scheduled Ancient Monument. There is some contention as to whether the mound on which the castle stands is natural or part of an earlier motte-and-bailey castle. There is a claim that the stone for the construction of the tower may have been taken from Hadrian's Wall.

The attached three-story seven-bedroom house has a date stone showing 1669, and the building was greatly remodelled by Newcastle architect John Dobson (1826–90). The castle is under the custodianship of the National Trust and the house is leased as a private residence.

The castle does of course have a ghost tale, allegedly haunted by the Grey Man, who was a travelling minstrel. It appears that the then owner of the castle, Lord Blenkinsopp, unjustly accused the man of being a Scottish spy and had his servant set their dogs against him. The minstrel was torn to shreds by the dogs and now haunts the place of his death.

One other myth concerns an old sycamore tree which stands in the grounds of the castle. It is known as the 'hanging tree' and the tale is that it was used by Cavaliers to execute captured Roundheads during the Civil War.

Haltwhistle

The market town of Haltwhistle lies at the end of the South Tyne Valley, the River South Tyne turning eastwards to head towards Tynemouth and the North Sea. Exchanging one valley for another, Haltwhistle is in the Tyne Valley, also referred to as the Tyne Gap. An ancient name for the town is Hautwysel which comes from the Old English meaning 'fork of a river by a hill'.

The town brands itself as being the centre of Britain; this is based on it lying in the centre of the longest line of latitude running through the country. It is often said that a pin placed under Haltwhistle would enable Britain to be finely balanced. Certainly this fact adds to the tourist appeal of the town; however it also attracts visitors as Hadrian's Wall is within 3 miles (5 kilometres) and the Pennine Way walking route passes right through.

Lying on the important east to west road route which links Newcastle upon Tyne with Carlisle, the A69 passes Haltwhistle. While this is now via a bypass, the road at one time did come through the town. The main line also passes through the town.

Historically a settlement may have been here since the time of the Roman occupation, a small fort having been discovered at Haltwhistle Burn which runs through the town and empties into the River South Tyne. However, an earlier example of potential Bronze Age habitation in the area is the Mare and Foal stone circle, which lies to the north-east of the town. In the twelfth century the town was ruled as part of Scotland, with reference to a charter being granted in 1178 by William the Lion of Scotland for the income from church lands in the Manor of Haltwhistle to be paid to the Benedictine abbey of Arbroath.

Given its position close to the Anglo-Scottish Border, the town had many substantially built fortified stone buildings, which could withstand attack from the likes of Scottish outlaws. An area of Haltwhistle, Castle Hill, now residential houses, was in a fortified mound in the twelfth century which overlooked the town and offered protection to the inhabitants. Writing in 1828, Archdeacon Singleton described Haltwhistle as 'full of uncouth but curious old houses which betoken the state of constant insecurity and of dubious defence in which the inhabitants of the Border were so long accustomed to live'. England must have regained Haltwhistle by 1306 as King Edward I rested his troops there in 1306 prior to his army marching into Scotland. In recognition of the hospitality from the townsfolk he granted the right for a market to be held.

The Centre of Britain Hotel, formerly The Red Lion Hotel, is a good example of the defensive houses of the past. Grade II* listed, it contains at its core the remains of a pele tower dating from the fifteenth century when a tower house stood on the site. The house is reported as having been used as a base by the lord warden of the Middle Marches. The lord warden had responsibility for security on the border and administered the March Laws, which governed and ruled upon cross border disputes.

Looking over the Tyne Valley is the Grade I Listed Holy Cross church. There is evidence that a church has stood on this location since Saxon times, the building dates from the thirteenth century and there is evidence to suggest that the chancel dates from a previous church of the twelfth century. The church underwent a major restoration in 1870 by the Newcastle architect R. J. Johnson (1832–92), among the works being the nave west end and bellcote rebuilt; lancets inserted in aisles; roof pitches heightened; interior redecorated. The churchyard contains several Grade II Listed headstones.

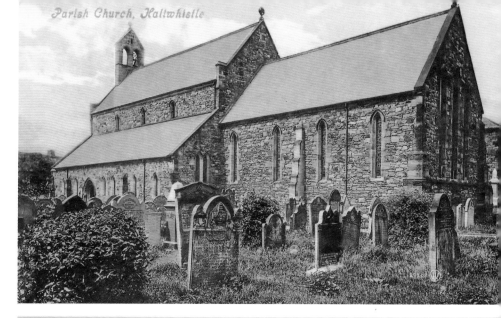

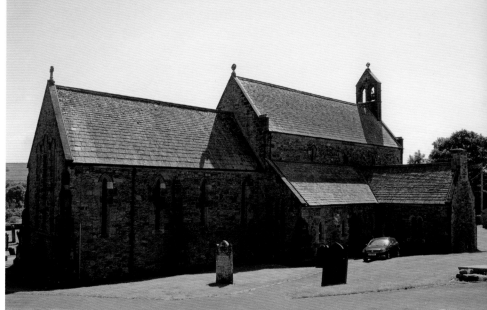

Above: Holy Cross church, Haltwhistle, old postcard view.

Below: Holy Cross church, Haltwhistle, modern view.

The population of Haltwhistle grew with the coming of the railway in 1838 when the station on the Newcastle–Carlisle line was opened and again in 1852 when the Alston–Haltwhistle line came into operation. Resident numbers doubled in the period 1840–1900. The railway stimulated industrial activity and allowed goods to be transported further and quicker. By this time several industries had opened on the banks of the Haltwhistle Burn, surrounding coalmines and quarries being able to increase production.

The railway station continues to serve passenger traffic and is much the same as when it was built in 1838. The station house, which was the home of the stationmaster, is now a private residence and with the ticket office and waiting room was thought to have been designed in a Tudor style by Newcastle architect Benjamin Green (1811–58). As a testimony to the days of steam-driven trains, a water tank dating from 1863, designed by the Newcastle and Carlisle Railway's engineer Peter Tate and built by R. Wylie & Co., survives. The Grade II listed building was restored in 1999 and now provides office accommodation at ground level. The cast-iron footbridge which links the north and south platforms is also of historical interest, being Grade II listed it was erected in the nineteenth century for the North Eastern Railway. Erected at the same time was the signal box, which is located on the south platform, another Grade II listed building in the station. A weather-boarded two-storey building with a Welsh slate roof, the signal box was given a National Railway Heritage Award in 2003.

The earliest known bridge crossing the River South Tyne at Haltwhistle was a wooden built bridge which dates from the nineteenth century. Before the bridge was built, a ford and ferry was used to cross the river. Nowadays the town more than makes up for its late association with bridges with its five crossings, two road, two pedestrian and one former railway viaduct. The Grade II listed Alston Arches Viaduct is the most spectacular of the crossings. Designed to carry the Alston–Haltwhistle service on the Newcastle & Carlisle Railway line, the architect was Sir George Barclay Bruce who was also responsible for the previously mentioned Lambley Viaduct. The viaduct was opened on 17 November 1852. The stone built viaduct follows a skewed route across the river. It has six arches, with four spanning the water. An interesting feature is that each arch in the river is cut away at its base to form round arched openings, which may have been intended to support a pedestrian bridge. Also at river level is a fish pass, which allows migrating salmon to pass over the weir. The branch line closed in May 1976 and the last train passed over the viaduct on 3 May. In 2006 the viaduct was restored and opened as a public walk way and officially opened on 10 July 2006 by HRH The Duke of Gloucester.

Opposite: Alston Arches Viaduct, looking east.

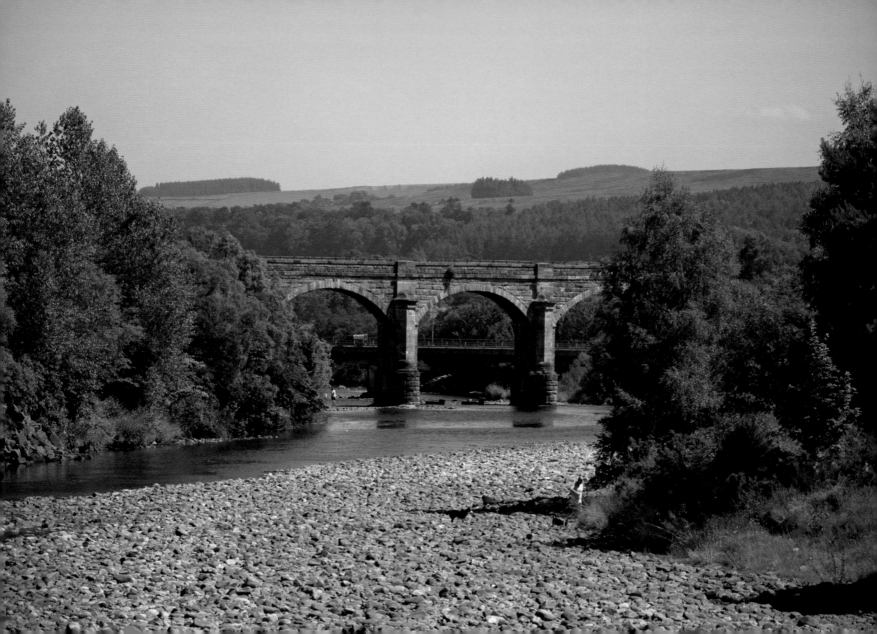

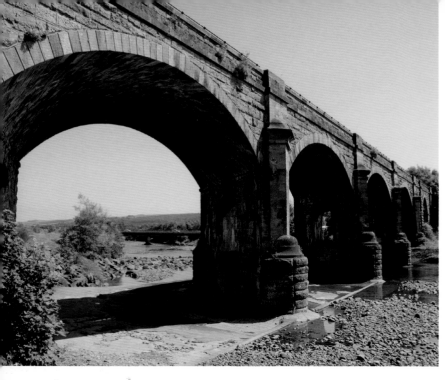

Alston Arches Viaduct, looking south.

Bardon Mill

To the east of Haltwhistle and on the south bank of the River South Tyne is the small village of Bardon Mill, its name is derived from the Middle English for 'mill near Bardon'. In Old English, 'Bardon' translates as 'barrow hill', a barrow being a prehistoric burial mound; there are several barrows in the area.

The largest building in the village is the Errington Reay & Co. Ltd pottery, which is the only licensed producer of salt glazed pottery in the UK. It was originally built in 1760 as a water-powered wool mill. A fire in 1876 caused a change in business when the wool mill machinery was destroyed. The mill was then converted into a pottery by Robert Errington and William Reay for the manufacture of salt glazed sanitary ware. Today the pottery still practices the traditional way of manufacture, such as hand-thrown clay and products dried in coal-fired down draught kilns. The production of salt glazed clay involves the kiln being heated to 1,260 degrees. Salt is then thrown into the kiln, which vaporises and reacts with the silica in the clay and results in the salt glaze. The process takes two days to complete.

Bardon Mill has a station on the Newcastle–Carlisle Railway and its Grade II listed stationmaster house is similar to the one at Haltwhistle, again designed by Benjamin Green. It is now a private residence.

Langley Castle

Located on the south side of the River South Tyne and standing beside the Langley Burn is Langley Castle, a Grade I listed thirteenth-century tower house which these days operates as a hotel. The name Langley is from the Old English for 'long clearing'.

Originally owned by Sir Thomas de Lucy, the building passed to the Earl of Northumberland (Percy family) following the death of Sir Thomas in 1343. Unfortunately, Percy was involved with Bishop Richard le Scrope (1350–1405) in the Northern Rising against King Henry IV. The result of the revolt was that Scrope was beheaded on 8 June 1405, his last request being that he be dealt five blows in remembrance of the five wounds suffered by Christ at his crucifixion. During the uprising, the King's army attacked and destroyed Langley Castle and it lay in ruins.

Over 470 years later, the ruined building was purchased by local historian Cadwallader Bates, who set about restoring the castle. With the assistance of his wife, Josephine, Bates worked on the restoration until his death in 1902. On his death, Josephine took over the project and worked until her own death in 1933. Both are buried within the grounds of the castle.

In subsequent years the castle has been used as a barracks during the Second World War, a girl's school and finally a hotel.

A notable feature of the castle is the large number of toilets, known as garderobe, a total of twelve with four to each floor. It is unusual to have such a high number of garderobe, most typical castles only have one or two and it is thought that it may have been the intention to have a large garrison of troops housed.

Bardon Mill Pottery.

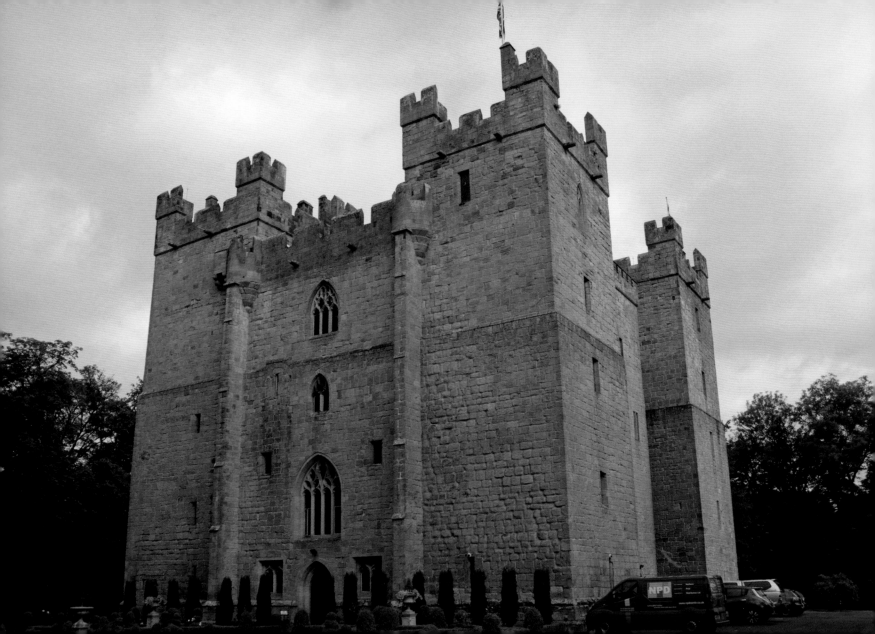

Haydon Bridge

Lying on both the north and south sides of the River South Tyne is the village of Haydon Bridge. Haydon in Old English means 'hay valley'. The bridge is first recorded in 1309 when there is the inquest of Thomas, Baron of Langley, who was described as living '*apud Pontem de Haydon*', loosely translated as next to Haydon Bridge.

A popular place for passing tourists, the village has a number of hotels and bed and breakfast accommodation. Additionally, it is well served to quench the thirst with three pubs: The Anchor, The Railway Hotel and The General Havelock Inn. There is also a workingmen's club.

There has been a railway station at Haydon Bridge since 1838, on the Newcastle–Carlisle line, one effect being that the population very quickly doubled. Additionally, the availability to transport goods quickly and in bulk allowed more industry to grow. Indeed, Haydon Bridge had its own freight yard adjacent to the station and closed in the 1970s. The railway also allowed professionals to daily commute to Newcastle and Carlisle.

Two bridges cross the river in the village centre. There is the now 'old' Haydon Bridge, which dates from 1776 and is now used for pedestrians, along with its replacement, the modern-day road bridge, which commenced in 1967 and was completed

Above: Haydon Bridge, the 1970 road bridge.

Below: Haydon Bridge, the ancient bridge.

Opposite: Langley Castle.

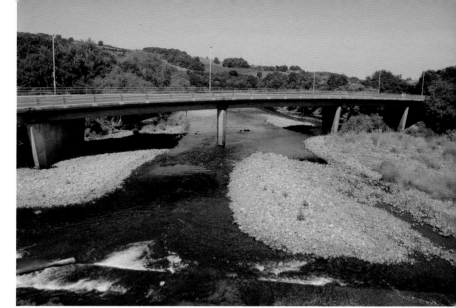

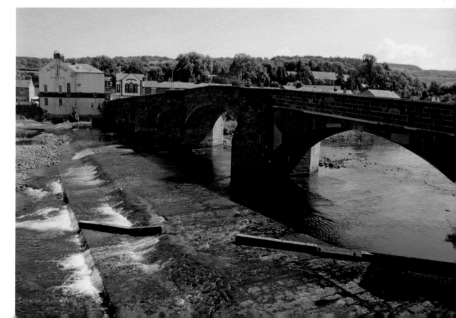

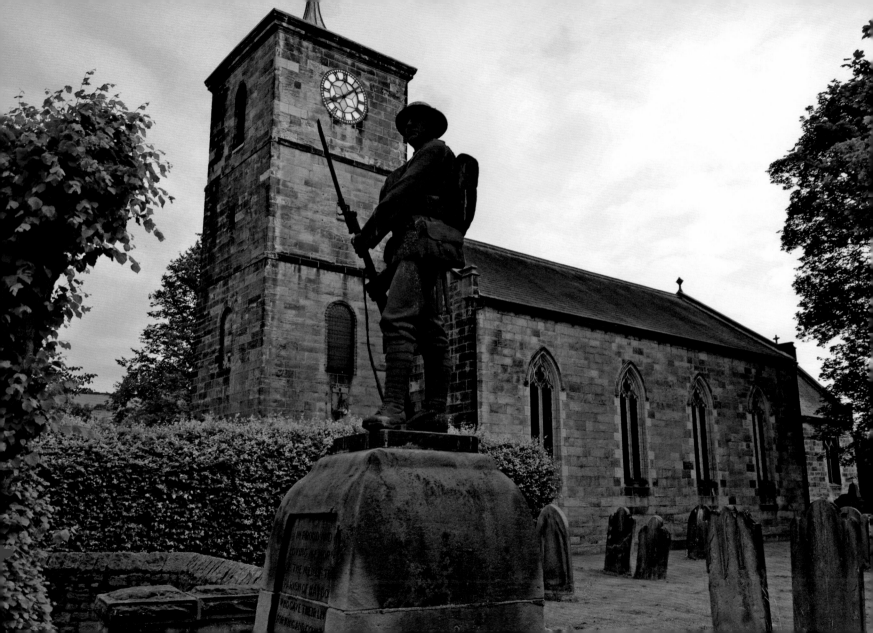

in 1970. The A69 trunk road used to be routed through the village but a new bypass was opened to the south in 2009 which included a new bridge taking traffic over the river, so technically the village now has three bridges.

The 1776 six arch bridge replaced an earlier one which was severely damaged by the Great Flood of 1771. The earliest reference to a bridge is in the inquest report mentioned above and it was probable that it was wooden in construction with gates and guards to control passage.

John Sykes, writing in his Local Records, reported this incident which occurred on 21 December 1806:

About ten o'clock on the morning, one of the arches of Haydon Bridge, about 95 feet in span, which had long shewn evident signs of weakness and decay, fell with a tremendous crash, just at the time a number of people were passing to church. One unfortunate man sunk with the ruins to the depth of forty feet, but was taken out alive, with a broken thigh bone and otherwise much bruised.

Lasting until 1967, the old bridge was closed to traffic as it had become unsuitable to the weight and size of the modern day motor vehicle. A temporary bridge was installed while the new road bridge was built and the new crossing point opened in 1970. The old bridge is Grade II listed and now carries only pedestrian traffic, offering a pleasant walk from one side of the river to the other.

The village is served by the Anglican parish church of St Cuthbert's, which dates from 1796 and is Grade II* listed. The Greenwich Hospital Commissioners funded its construction with stone being used from the partial demolition of the medieval old Haydon Bridge chapel. A damaged fourteenth-century effigy under crocketed canopy was also relocated here from the chapel. Modifications were made to St Cuthbert's in 1865 when the north transept was added and in 1898 the chancel was enlarged and the southern elevation Gothicised. Standing to the front of the church is a memorial to both world wars. The memorial is Grade II listed and has a life-size bronze statue of an infantryman carrying a rifle designed by George Percy Bentham (1883–1936).

Opposite: Church of St Cuthbert, Haydon Bridge.

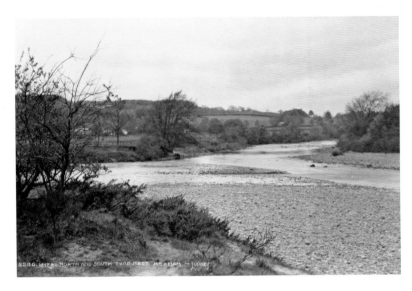

Above: Warden Rock, old postcard view.

Opposite: Warden Rock, modern view.

Marriage of the Tynes – Warden Rock

The rivers North and South Tyne meet at Warden Rock to form the River Tyne, the confluence of the two bodies of water being known as 'The Meetings of the Waters'. However, I much prefer the term of 'Marriage of the Tynes', as referenced in an old minstrel song in *The Tyne and its Tributaries* by William James Palmer. In that book, Palmer writes,

> But no one sings the marriage of the Tyne's of South Tyne with North Tyne, South Tyne, a son of toil, from fountain-head and earliest springs associated with mines and beautiful North Tyne, a daughter of the moors, is she not known as the brightness of the smiling haughs, and joy of flocks which come down by her noon? Well under Warden Hill, these two streams become one, they come swiftly and joyously to their union, but now take a more dignified pace, flowing at leisure past Hexham's ancient towers, by Beaufront, Dilston, Corbridge, and the green lawns of Bywell, soon, however, to resume work, increasing work, of pastoral service less and less, and finally there remains for Coaly Tyne but one long working day, midst smoking chimneys, blazing furnaces, and forests of masts, until it reaches THE SEA.

From this point the North Tyne has run for 43 miles (69 kilometres), the South 42 miles (68 kilometres) and the now formed River Tyne continues for another 35 miles (56 kilometres) to the North Sea – a total distance of 120 miles (193 kilometres).

THE TYNE – HEXHAM TO THE NORTH SEA

Hexham

The first market town on the Tyne, Hexham lies 2 miles east (3 kilometres) from the Meeting of the Waters. It lies on a glacial terrace, 66 feet (20 metres) above the south bank of the river. Several streams or burns run through the town, which include Cockshaw Burn, Halgut Burn and Skinner Burn and all feed into the Tyne.

The meaning of Hexham as a name is a little convoluted. In AD 681 it was known as Hagustaldes ea, meaning 'stream of Hagustad'. In Old English, *Hagustaldes* (Hagustad) means a young man who has to set up an enclosure for himself outside of the settlement he was born in. At a later date the 'ea' part of the name was changed to 'ham'; translated in Old English as 'homestead'.

The first recorded mention of Hexham arises in 674 when Wilfrid, a former monk of Lindisfarne who had become Bishop of York, was awarded land by Queen Etheldreda of Northumberland to build a church and Benedictine monastery. Wilfrid was canonised as Saint Wilfrid.

The church, built by Wilfrid between 675 and 680, is Hexham's most notable buildings, was dedicated to St Andrew but these days is more usually known as Hexham abbey. It was claimed to be the finest church north of the Alps. Situated in the centre of the town, it is open to the public and well worth a visit to appreciate the fine Grade I listed building and also to the numerous artefacts on display. The original church was built mainly by overseas craftsmen and made from stones recycled from the abandoned Roman fort at nearby Corbridge. Examples of the Saxon church can still be seen within the fabric of the current building, including the original crypt. Over the years the abbey has been much modified and enlarged from the original church and monastery, most of the building dating from the eleventh century. Rebuilding has been required over the centuries due to both the abandonment of the monastery and attacks over the years by Vikings and Scottish raiders. During the nineteenth century, Newcastle architect John Dobson carried out various modifications to the east front exterior in an attempt to model an example of Whitby abbey. Pevsner describes this aspect as 'a disappointing Victorian east front of 1858 by Dobson'. The nave was rebuilt by architect Temple Moor (1856–1920) in 1908, having previously been destroyed in 1296. Parts of the original walls were used in the rebuild and can be distinguished from the new stone by their darker colour.

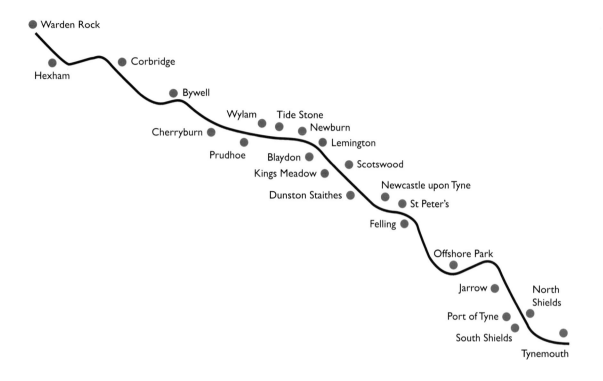

Warden Rock

Hexham

Corbridge

Bywell

Wylam Tide Stone

Cherryburn Newburn

Prudhoe Lemington

Blaydon

Kings Meadow Scotswood

Dunston Staithes Newcastle upon Tyne

St Peter's

Felling

Offshore Park

Jarrow North Shields

Port of Tyne

South Shields

Tynemouth

Map of the River Tyne (not to scale).

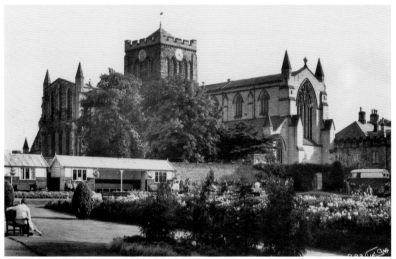

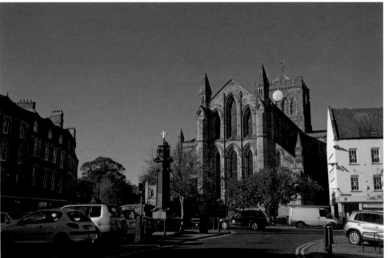

Above left: Hexham abbey, modern view.

Above right: Hexham abbey, old postcard view.

Left: Hexham abbey east end.

Close to the east end of the abbey is the Saxon marketplace and the Grade I listed medieval moot hall. The latter dates from the fourteenth century and was the seat of the town's courts. It also acted as a gateway and a defensive tower during Hexham's troubled times, of which there were many. For instance, in 1297 the town was sacked by William Wallace's Scottish army. Following the Battle of Hexham in 1464, during the War of the Roses, fought to the south of the town, the Lancastrian commander, Henry Beaufort, Duke of Somerset, was beheaded in the marketplace and buried in the abbey. The marketplace

was also the site of the deaths of fifty-one protestors during a riot on 9 March 1761. A meeting had been held to oppose the changes proposed to the rules affecting conscripted military service by ballot. A detachment of the North Yorkshire Militia had been brought into the town to keep order and, following the reading of the Riot Act, had opened fire on the crowd. Peace now reigns in the marketplace with stalls still selling goods beneath the Grade II* Shambles, an open building with Tuscan columns on three sides and wooden posts on the other said, erected by Sir Walter Blackett in 1766.

Worthy of mention is also the Grade I listed old gaol (also known as the former manor offices) which is open as a museum and art gallery. Built in 1330 on the order of Archbishop Melton of York as a prison, it remained as such well into the nineteenth century. It also acted as a defensive tower and is another Hexham building that contains stones robbed from the Roman fort at Corbridge.

The main road bridge crossing the Tyne is Hexham Bridge, which is located in an area known as Hexham Green, north of the town. While the present bridge has survived since 1798, five bridges in previous years had been destroyed by the flood waters of the Tyne. The earliest known bridge was built in 1770. A stone bridge of seven arches, it was erected by William Gott but was swept away in the Great Tyne Flood of 1771 when every bridge downstream with the exception of the one at Corbridge was destroyed. Prior to the 1770 bridge, passengers and goods were transported across the river by two ferries known as the East and West Boats.

The present Hexham Bridge dates from 1798 and was built under the supervision of the Edinburgh-born engineer and architect Robert Mylne (1733–1811). The actual design of

Hexham marketplace, old postcard view.

the bridge had been drawn up by John Smeaton (1724–92) when he built the Hexham Bridge of 1780. However, several arches of that bridge were destroyed in a flood of 1782. Grade II* listed, the current bridge is built from stone and has nine arches. The weir to the east of the bridge is one which is formed from the foundations of a previously destroyed bridge. During the salmon migration season, the bridge makes an ideal platform to watch the fish jumping over the weir to head upstream to lay their eggs in the upper reaches of the river. The Tyne is claimed to be one of the best salmon rivers in England and Wales. Salmon lay their eggs in the exact place that they themselves hatched and it is estimated that around 30,000 pass through the Tyne each year.

Corbridge

Corbridge lies 4 miles (6 kilometres) downstream from Hexham and is a market town which sits on a river terrace on the south bank of the Tyne. The town takes its name from its firm Roman links. The Roman fort of Corstopitum lies to the west of Corbridge and evidence has been translated from Roman writing tablets found at Vindolanda that the town was originally named Coria. Corstopitum was a vital link in the Roman road system, standing at the crossroads of the Stanegate (North Sea to Irish Sea) and Dere Street (York to Scotland).

To enable Dere Street to cross the Tyne a bridge was built in AD 160 by the Romans at Corstopitum, thought to be a low bridge, made from stone with up to eleven arches. During 2008, the remains of the bridge were excavated in a project between English Heritage and Tyne & Wear Museum, funded by the Lottery Heritage Fund. The archaeological dig was forced by serious erosion of the remains which was occurring, mainly due to the Tyne changing its course since Roman times. Stone blocks from the bridge can still be seen on the bed of the Tyne. When the Romans withdrew from the North of England in the fourth century, the bridge fell into disrepair and ultimately a ford further to the west was used as a crossing point. It was at this ford that the medieval town grew and there is evidence that stone from the bridge was taken by the local inhabitants and used in its buildings.

The oldest building in the town is the Grade I listed St Andrews church, the parish church of Corbridge, which was consecrated

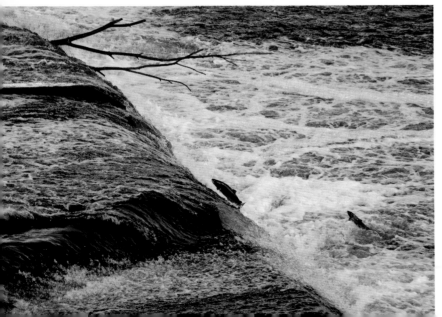

Above: Hexham Bridge.

Below: Salmon leaping the weir at Hexham Bridge.

in 676. It has been suggested that Wilfrid may have built the church at the same time as Hexham abbey. The church is one of those buildings made from recycled stone from Corstopitum. Pevsner makes the observation that the church is 'the most important surviving Saxon monument in Northumberland, except for Hexham crypt'. The church has changed a lot since its origins. In 1919 the south porch was added. Rowan Atkinson, the comedian and actor, donated a decorative glass door for the south porch in 2008 as a memorial to his late mother, Ella May.

Standing to the east of the church is the Grade I listed vicar's pele, a thirteenth-century defensive tower which provided housing as the name suggests for the priest at St Andrews. Being close to the Anglo-Scottish Border, the town of Corbridge was often the target of attacks and that is why the vicar required a place of safety. Another building which uses the stones from Corstopitum and the gabled roof dates from 1910. It was used as a vicarage until the seventeenth century.

The Grade I listed bridge at Corbridge has stood since 1674 and was the only one to survive on the Tyne during the Great Flood on 1771; all the others were swept away or damaged. I was not a case of the bridge being so strong that it was able to withstand the force of the flood waters, but more that to the south of Corbridge is a large floodplain which enabled the river to break its banks and divert around the bridge. John Sykes, writing in his book of Local Records, described the scene as,

> The water at this place was so tremendous, that some persons, late in the night, stood upon the bridge and washed their hands in the rolling river. The preservation of this bridge was attributed

to its Roman foundation and a vast quantity of water having passed it at its south end, which is low ground.

The bridge is built from stone with seven unequal segmental spans, 479 feet (147 metres) in length; the southern arch was rebuilt in 1829. Widened in 1881, the bridge now carries single-lane traffic.

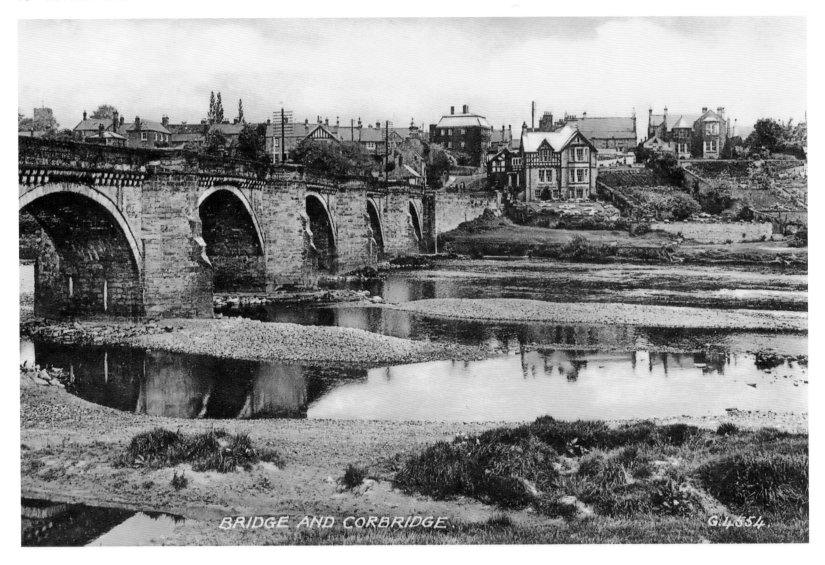

BRIDGE AND CORBRIDGE. G.4554.

Bywell

Lying on the north bank of the Tyne, Bywell can only be described these days as a hamlet, but in its time it was once a thriving town. Named after the bend in the river at which it is located, the Old English name *byge-wlla* means 'wellspring in a bend'.

Nowadays, Bywell consists of a few houses, two churches, a castle and a mansion house. However, in the sixteenth century it was a small town, as described by a survey carried out by the Royal Commissioners in 1570:

> The town of Bywell is built in length all in one street upon the river of water of Tyne, on the north and west part of the same and is divided into two several parishes and inhabited with handy craftsmen whose trade is all in iron work for the horsemen and borderers of that country as in making bits, stirrups, buckles and such other, wherein they are very expert and cunning and are subject to the excursions of the thieves of Tynedale, and are compelled winter and summer to bring all their cattle and sheep into the street in the night season and watch both ends of the street and, when the enemy approaches, to raise hue and cry whereupon all the town prepares for rescue of their goods which is very populous by reason of their trade, and stout and hardy by continual practice against the enemy.

The demise of Bywell was caused by the Great Flood of 1771 when ten houses were washed away and six people lost their lives.

The fact that Bywell has two churches is explained not only by the fact that there was a larger congregation to serve but more importantly that two estates once intersected at the town, owned by the barons of Balliol and Bolbec. Thus, each

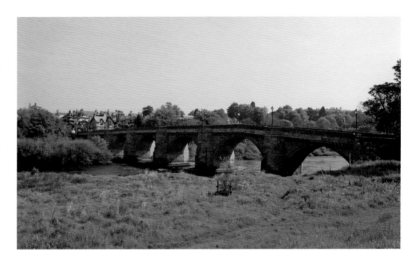

Above: Corbridge, modern view of the bridge.

Opposite: Corbridge, old postcard view of the bridge.

estate had its own parish church, commonly referred to as the White Church (St Andrew) and the Black Church (St Peter). Historically, the use of the colours relates to St Peter having been granted to the Benedictine black monks at Durham and St Andrew to the Premonstratensian white monks at Blanchland.

Arriving in Bywell, the first church to be seen is the Grade I listed St Andrew's, which lies to the right-hand side of the road opposite the village cross. The church no longer holds regular services but its churchyard is open to the public. The church dates from the eleventh century. However, in the nineteenth century it was remodelled by the architect John Dobson and the London based architect William Slater (1819–72). Medieval cross slabs have been incorporated into the external north wall of the church.

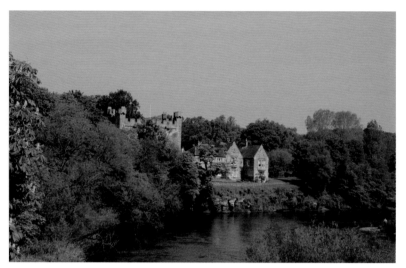

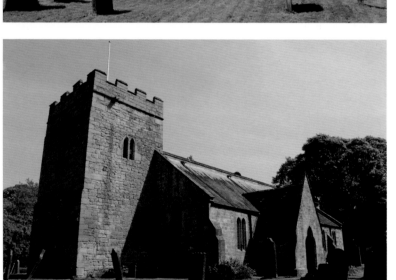

Above left: St Andrew's church, Bywell.

Above right: Bywell Castle.

Below: Church of St Peter, Bywell.

The church of St Peter lies next to the Tyne and may predate St Andrew's, with evidence of it having been built in the eighth century. Alterations were made by the London based architect Benjamin Ferry (1810–80) when the south aisle was rebuilt and the vestry added. Services are still held at this church and the churchyard is still in use. The church has several nineteenth-century stained-glass windows in remembrance of the Wailes family. The windows are attributed to Newcastle-born William Wailes (1808–81) who was a renowned stained glass designer and who is himself buried in the churchyard.

Bywell Castle is a Grade I listed gatehouse tower built in the fifteenth century for Ralph Neville, the second Earl of Westmoreland. It may stand on the site of an earlier castle built by Guy, Baron of Balliol, in the eleventh century. The remains of the castle have been incorporated into the nineteenth-century Bywell Castle House. Unfortunately, as a private residence the grounds and building are not open to the public.

The Grade II* listed Bywell Hall was built as a grand villa by the English architect James Paine (1717–89) in 1766. It was built for William Fenwick, son of John Fenwick, who was the high sheriff of Northumberland. Now it is owned by the Allendale Estate and is open to the public between April and August.

Fishing rights on the Tyne at Bywell are under the private ownership of the Allendale Estate, a 2.5 mile (4 kilometres) section of the river which affords excellent sport.

Above: Cherryburn House.

Right: Thomas Bewick.

Cherryburn

Thomas Bewick (1753–1828), the famous artist, wood engraver and naturalist, was born at a cottage called Cherryburn House, part of a farm located not far from the village of Mickley on the south bank of the Tyne.

The Grade II listed cottage is under the guardianship of the National Trust, who have opened it to the public. Given the position of his home overlooking the Tyne Valley, it is little wonder that Bewick had an appreciation of nature.

Bewick is well known for his wood engravings, which were used to print his artwork and eventually used within the books that he himself wrote, illustrated and published.

Prudhoe

The town of Prudhoe lies on the south bank of the Tyne, the name coming from the Old English for 'Pruda's hill spur'. On the opposite side of the Tyne is the village of Ovingham. Both villages are linked by a single lane bridge which was built in 1883 to replace a cross river ferry.

From a steep ridge overlooking the Tyne Valley is the Grade I listed and Scheduled Ancient Monument Prudhoe Castle, built in the eleventh century for the D'Umfraville family. Sir Robert de Umfraville had been granted the land by William the Conqueror. The remains of the castle are under the custodianship of English Heritage and open to the public.

Historically, the castle is one that is unique in Northumberland, as it was the only one never to have been captured and occupied by the Scots. It was, however, besieged on two occasions, 1173 and 1174, by King William of Scotland (William the Lion). Perhaps the position of the castle on its high ridge, the north and east sides protected by a steep fall away to the valley floor and the moat to the south and west sides afforded the castle protection against the Scots. However, during the English Civil War it was occupied without any notable force by both sides – the Parliamentarians and Roundheads.

In ancient times, Prudhoe Castle appears to have been used as a pawn between the King and its owners with ownership changing on several occasions. As was common in medieval times, any failure to align with the English throne resulted in forfeiture of lands and, in many occasions, execution. Ultimately, the castle became the property of the Earls of Northumberland, the Percy family and it remained so until 1966 when it was gifted to the Crown.

The curtain wall remains more or less intact, as does the barbican gate and towers to the north west and south west. The gatehouse is well preserved and contains a chapel on its upper level. Only a high wall of the original keep is present and was replaced with a Georgian manor house by Hugh Percy, 2nd Duke of Northumberland, between the years 1808 and 1817. The manor house now holds a visitors centre and exhibition gallery.

Wylam

Wylam village is located on the north bank of the Tyne; its name is rather mysterious in origination but may come from the Old English meaning 'at the trap or watermill'.

The earliest record of a settlement is in 1158 when a record indicates it was under the ownership of the priory of Tynemouth. The Lord of Bywell, Baron Guy De Baliol, may well have granted the lands to the priory. After the Dissolution of the Monasteries, the lands came into the hands of the Blackett family.

Wylam is perhaps known mainly for its connection with the pioneers of the locomotive engine. George Stephenson (1781–1848) was born in Wylam, in what is now known as Stephenson Cottage, which lies to the east of the village. Timothy Hackworth (1786–1850), the steam locomotive engineer, was born in Wylam. William Hedley (1779–1843) was another engineer associated with early steam engines and he went to school in Wylam as well as being at one time the manager of the Wylam Colliery.

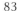

Above left: Prudhoe Castle.

Above right: Stephenson Cottage, Wylam, modern view.

Below: Stephenson Cottage, Wylam, old postcard view.

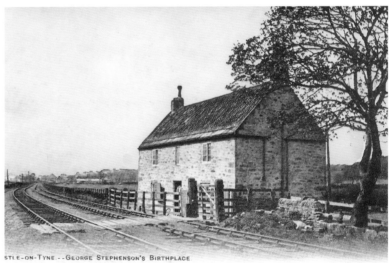

STLE-ON-TYNE.--GEORGE STEPHENSON'S BIRTHPLACE

During the eighteenth century, Wylam was a thrive of industrial activity, the colliery producing coal which was used locally as well as being taken by a waggonway to Lemington to the east for transport by river down to Newcastle for export. Also in the village were an iron foundry, brewery and lead shot factory, which by the latter end of the nineteenth century had all closed, leaving it mainly residential as it is today. The village is served by the Newcastle–Carlisle line and many of the residents commute to work in nearby Newcastle upon Tyne.

Stephenson Cottage lies half a mile (0.8 kilometres) to the east of the village and is reached via a pleasant walk along the former waggonway. Under the custodianship of the National Trust, it is open to the public with the exceptions of Mondays, Tuesdays and Wednesdays, unless one of those days falls on a bank holiday in which case it is open. A Grade II* listed building, it dates from the eighteenth century. A young George would have been aware of the movement of coal as the waggonway was to the immediate front of the cottage, with the Tyne being a matter of yards beyond. His father, Robert, was a fireman at the Wylam Colliery pumping engine and therefore he may have had an understanding of mechanics from a young age.

St Oswin is the parish church for Wylam and was built in 1886 by R. J. Johnson from funds donated by the Hedley family to commemorate the railway engineer William Hedley. The church is Grade II listed. For a small church it has a high number of bells – six in total.

Two bridges cross the Tyne at Wylam – a road bridge and a disused railway bridge. Until 1836, the river had been crossed by way of a ford, but with the introduction of the railway line on the south bank there was a desire by the businesses in the village to have goods transported by rail. A joint road and railway bridge was erected in 1836; there is some debate as to who was the architect, either engineer Benjamin Thompson (1779–1867) or engineers John Blackmore (1801–44). Constructed as stone piers supporting a wooden deck, it was used as a rail crossing until 1890. By 1897, the bridge had been replaced with a steel road bridge by the Wylam Toll Bridge Co. The toll was removed in 1936 when Northumberland County Council purchased the bridge, replacing it in 1946 and again in 1960 when the present crossing was constructed by the firm Dorman Long.

The second bridge is the Grade II* listed West Wylam Railway Bridge, known locally by a variety of names based on its design: Half Moon Bridge, Bird Cage Bridge and Tin Bridge among others. The bridge crosses the Tyne half a mile (0.8 kilometres) to the west of the village at Haggs Bank. It was constructed in 1876 to link the Scotswood, Newburn & Wylam Railway with the Newcastle–Carlisle Railway. Designed by Tynemouth-born engineer William George Laws (1836–1904), it is a single span wrought-iron arch with a suspended railway deck. Often referred to as resembling the Tyne Bridge, it was closed to railway traffic in 1968, the rack removed in 1972 and it is now a bridle way linking Wylam to the Tyne Riverside Country Park at Prudhoe.

Headwin Stream – The Tide Stone

Located to the side of the Riverside Walk between Wylam and Newburn at a location called Hedwin Streams is the ancient marker of what was in the eighteenth century the high-tide mark of the Tyne. Nowadays, the high tide is further upstream at Wylam.

Opposite: Wylam St Oswin's church.

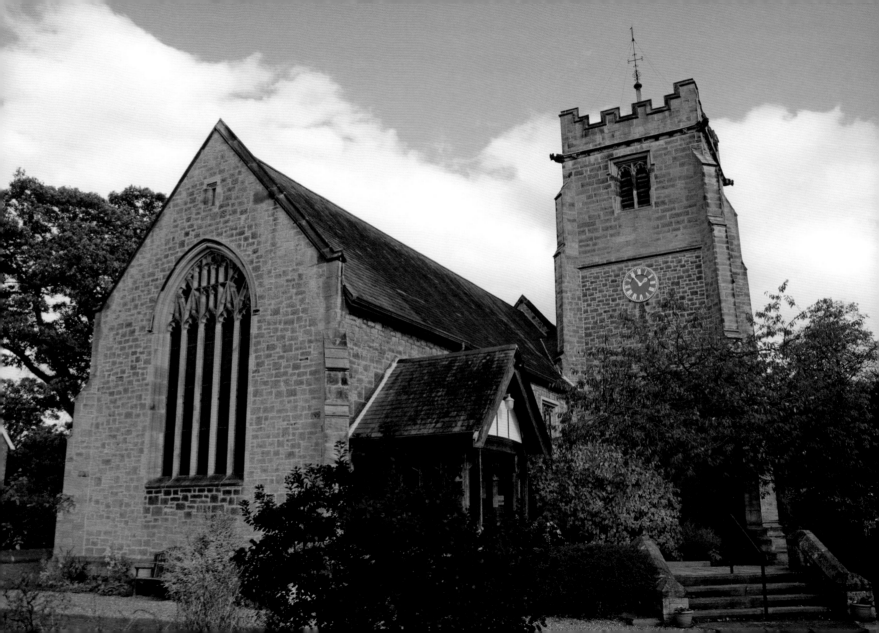

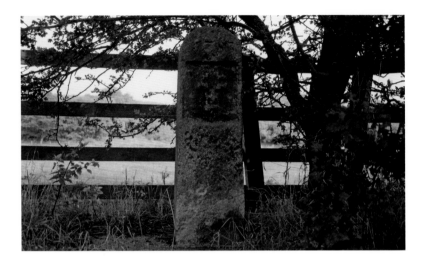

Tide stone, Hedwin Streams.

It is Grade II listed and dates from 1783. It is made from stone and carries the Newcastle upon Tyne shield (three castles); although much weathered, it measures 3 feet (0.91 metres) in height.

The tide stone was erected to mark the boundary of the waters of the Tyne that were controlled by the Tyne Improvement Commission (now Port of Tyne Authority). The distance covered by tides on the Tyne from the tide stone to the North Sea is 19 miles (30 kilometres).

The Corporation of Newcastle upon Tyne in the past surveyed the bounds of its area each Ascension Day. This would entail the mayor of Newcastle and guests travelling the length of the Tyne between Sparhawk at the mouth of the river to Hedwin Streams; the last such occasion was exercised in 1861. The mayor's barge would be used for the journey and by tradition the mayor would land on the shore and kiss whom he judged was the prettiest girl in the waiting crowd. The chosen girl would be given a sovereign coin, but the rumour is that the practice was eventually halted when it was found the recipient of the coin was a relative of the mayor. This proclamation was read out at the arrival:

> Proclamation is hereby made that the Soil of the River Tyne, wherever covered with water, between Hedwin Streams and Sparhawk is within the Borough of Newcastle-upon-Tyne, and belongs to, and is within the Jurisdiction of the Mayor, Aldermen, and Burgesses of the said Borough.

Newburn

Lying on the north bank of the Tyne is the village of Newburn, which historically was an important crossing point of the Tyne. Its shallows have possibly been used to ford the river since Roman times. Indeed, it is thought that a Roman fort may have guarded a ford at Newburn and this may explain the meaning of the original name of Newburn, Newburgh. In Old English the name Newburgh is translated as 'new fort'.

In 1346, King David II of Scotland and his army used the fording point at Newburn on his way to the Battle of Neville's Cross, Durham. That battle led to the defeat of the Scots and the capture of the Scottish King. The ford was also used by the Scots in the seventeenth century, when 20,000 members of the Scottish Covenanter Army, led by General Alexander Leslie, defeated the English forces of King Charles I at the Battle of Newburn (28 August 1640). They crossed the Tyne and went on to besiege and eventually capture Newcastle upon Tyne.

The oldest building in the village is the Grade I listed church of St Michael and All Angel, which dates from the twelfth century. Sitting on a hill overlooking the Tyne, the present building is predated by a wooden built Saxon church. It may well have been in this church that Copsi, Earl of Northumberland, was murdered in the eleventh century when it was set on fire by the troops of Osulf II of Bamburgh. Unfortunately, a second fire occurred in 2006 when severe damage caused the church to be restored at a cost of £2.6 million.

John Sykes in his Local Records reports an occurrence on 4 March 1832:

> The Reverend J. Reed was presented to the vicarage of Newburn, near Newcastle, vacant by the death of the Rev. James Edmondson, who fell a victim to the cholera morbus while that disease was raging in that village. No divine service having been performed there for some time in consequence of Mr Edmondson's death, on the above day (Sunday) the church was crowded to excess, and Mr Reed, after concluding a very impressive sermon, gave notice that he was then going to read the funeral service over their late vicar, and immediately proceeded to the church-yard, to which he was followed by about six hundred people, first to the grave of the vicar, and then to that of those who had been buried under similar circumstances, without the rites of the church having been performed over them. This was a solemn and affecting scene to the inhabitants of Newburn, where the effects of the cholera had been so awful

As with Wylam, there is a strong connection between Newburn and the railway industry. George Stephenson was employed at Water Row Colliery as an engineman at the age of seventeen

Newburn, St Michael and All Angel's church.

and was twice married, 1802 and 1819, at the church of St Michael and All Angel. William Hedley, the inventor of the steam locomotive Puffing Billy, was born in Newburn 1779 and his Grade II listed family tomb can be found in the churchyard. William Elsdon (1830–1904) was born in Newburn and went on to become an architect and railway engineer. Emigrating to Australia at the age of twenty-four, he worked on many railway projects in the state of Victoria.

The present single lane road bridge crossing the Tyne was erected in 1893 for the Newburn Bridge Co., designed by civil engineers Messrs J. W. Sandeman and J. M. Moncrieff of Newcastle and built by Head Wrightson of Thornaby. It was originally opened as a toll bridge, but following the

purchase of the bridge by Northumberland County Council in 1947 the toll was removed. The bridge was built close to the old ford crossing point and was designed to carry mains water across the river. The bridge is formed from four spans with a total length of 103 feet (31 metres). On the south bank of the Tyne and to the immediate west of the bridge can be seen the skeletal remains of a number of Wherries that were abandoned in the 1950s and allowed to rot. Wherries were wooden boats used on the industrialised Tyneside to transport goods on the Tyne. Slowly but surely the wooden craft have deteriorated and now their ribs stick out from the muddy bank of the river.

Lying beside the river, the village has always been prone to flooding, and evidence of this can be seen at the boathouse public house, which records on its external wall marks of levels of water reached in the years 1771, 1815, 1832 and 1856. In recent years, Newburn has suffered flood damage, not this time from the waters of the Tyne but from a small stream, Dewley Burn, which runs through the eastern side of the village. A culvert carrying the stream had collapsed during 2012 and owing to heavy rainfall in September of that year caused extensive flooding and the erosion of the foundations of a number of residential properties which led to their later demolition.

Opposite: The Boathouse, Newburn.

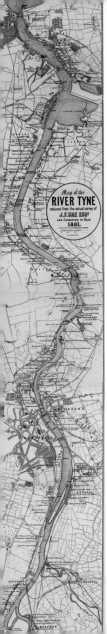

Blaydon – The Blaydon Races

The town of Blaydon stands on the south bank of the Tyne, it is best known for its association with the Blaydon Races which is immortalised in the Tyneside anthem written by George (Geordie) Ridley (1835–64). The song lyrics tell the story of a journey of racegoers on a horse-drawn carriage from Balmbra's music hall in Newcastle to Blaydon Races, 5 miles (8 kilometres) away, which took place on 9 June 1862.

The races originated as an impromptu race meeting held on a flat stretch of land known as Guards in the eighteenth century. The race at that time was associated with the Blaydon Hoppings (an annual fair) and included horse, pony and donkey racing. The original race had a prize donated by the Newcastle keelmen (watermen) which was known as the Keelmen's Purse.

The Guards site was used to construct Blaydon Railway station in 1835 and the racing was forced to end. However, the event was resurrected in 1861 when the first official Blaydon Race Meeting was held on Blaydon Island. The island in the Tyne was in the area now known as Newburn Haugh. The building of the railway station at Blaydon in 1835 allowed a wider audience to attend the new venue, with additional transport being the Blaydon omnibus from the cloth and biff markets in Newcastle. Additionally, steamers transported folks at all points between Shields and Blaydon. Makeshift bridges of barges were constructed to enable folk to get onto the island and others reached it by boat. The horses in the races had to wade across the river from Lemington on the north bank. The races were halted in 1870 when the Jockey Club ruled that the race prizes were insufficient. The last time the Blaydon Races were held was in 1916, being banned from that date owing to a riot which had broken out at the last meeting.

Map of the River Tyne 1881, by kind permission of the librarian at Robinson Library, Newcastle University.

Since 1981 the Blaydon Races has been remembered annually as part of a road race that follows the route from Balmbra's. It takes place on the evening of 9 June and covers a 5.7 mile (9 kilometres) course.

Lemington

On the north bank of the Tyne is the village of Lemington, the name being from the Old English for 'farmstead where brook lime (hleomoc) could be obtained'.

The Tyne used to run past the village but is now separated by a low-lying haugh. The course of the Tyne at this point was changed by the Tyne Improvement Commission when in 1850 they straightened a bend in the river to make navigation easier. The effect of this was that a small section of the Tyne was retained but not fed by the waters of the main river; it is known locally as Lemington Gut.

One of the consequences of the rivers diversion was that Lemington Glass Works lost the ability to easily transport its goods. The glassworks had been built in 1787 by the Northumberland Glass Co. and all that remains is the Grade II* listed brisk glass cone. Standing at 115 feet (35 metres) high, and 69 feet (21 metres) in diameter, now occupied as a car dealership. It is claimed that the cone contains some 1.75 million bricks, originally one of four at the glassworks. Production of glass at Lemington continued until 1997 when the glassworks was closed.

Scotswood

The Scotswood area has three bridges crossing the Tyne, Blaydon Road Bridge, Scotswood Railway Bridge and Scotswood Road Bridge.

Blaydon Road Bridge carries four lanes of the A1 trunk road across the Tyne and was opened by Her Majesty Queen Elizabeth II on 1 December 1990. The bridge was built as part of a project to build an alternative route for the A1 bypassing the congestion of Tyneside, remarkable as it may seem, the A1 at one time went through the centre of Newcastle upon Tyne. Designed by Bullen and Partners with building work by Edmund Nuttall, the bridge was built between 1987 and 1990 at a cost of £17 million. Using three cantilevers supported on two concrete piers the bridge is 1,089 feet (332 metres) long, 48 feet (14.6 metres) wide and the longest span is 354 feet (108 metres).

The Scotswood Railway Bridge lies unused and abandoned, although from time to time there are mentions of renovating it and opening it as a pedestrian and cycling crossing. It is not currently open to the public. The bridge formerly carried the Newcastle–Carlisle rail route (North Eastern Railway), carrying the line between Scotswood and Blaydon stations. The Newcastle–Carlisle line now travels over the King Edward VIII Bridge down river to the east and travels on the south side of the Tyne. The Scotswood Railway Bridge was used for goods trains

Above: Blaydon Road Bridge.

Below: Scotswood Railway Bridge.

Opposite: Lemington Gut, looking west.

up until the 1990s and was then closed. The bridge had earlier been closed to passenger traffic on 4 October 1982. The present bridge was erected in 1871 (strengthened in 1943), but there were rail crossings on that site built in 1839, 1861 and 1865. The original wooden built bridge from 1839 was destroyed by fire when ash from a passing engine set it on alight. The bridge measurements are 698 feet (212.6 metres) long and 25 feet (7.7 metres) wide. The rail deck has been removed but it still carries utility pipes on the underside.

Work began on 18 September 1964 to replace the Scotswood Suspension Bridge, which found it hard to handle the volume of modern-day traffic. The Old Scotswood Road Bridge, known as the Chain Bridge, had opened in 1831 and carried two lanes of traffic while the replacement carries four lanes. The new bridge cost £2.5 million, with 75 per cent met by central government and the remainder met jointly by the Newcastle Corporation and Durham County Council. It was designed by Mott, May & Anderson and built by Dorman Long & Kinnear Moodie Group Ltd. In addition to motor traffic, the bridge also carries utilities such as gas, water, sewers and water pipes. It has suffered from maintenance faults in the years since and was closed for several months during 1991 for essential repairs. It was opened by Alderman Peter Renwick on 20 March 1967. Measurements are 456 feet (139 metres) long and 66 feet (20 metres) wide.

As a youngster I remember the horror associated with walking across the old bridge to visit relatives on the southern side. The pedestrian deck was made from wood and every so often a plank was missing, revealing the waters of the Tyne below. It was with much trepidation that I would step over what seemed like a wide chasm.

Kings Meadow

A short distance from Scotswood Road Bridge and lying in Tyne used to be an island called Kings Meadow. It is no longer in existence, having been dredged away by the Tyne Improvement Commission in the nineteenth century to enable large ships to navigate to Lord Armstrong's munitions works at Scotswood. The island was 98 feet (30 metres) in length and a pub called the Countess of Coventry was located there. It is unclear how patrons of the pub would be able to avail themselves of refreshments, as the island was not linked to the bank of the river by a bridge, so it is probable that a small ferry operated to transport customers. The name is often the cause of speculation, with one 'theory' being King Charles I allowed his horse to graze upon the island when he was held for ransom by the Scots in Newcastle upon Tyne in the seventeenth century.

The island appears to have been used on occasions for horse racing, as detailed in this report by Thomas Fordyce in his Local Records of a visit by the mayor of Newcastle during the annual survey of the extent of the corporation's control of the Tyne on 8 May 1834:

The ancient custom of perambulating the boundaries of the river Tyne, of which the Corporation of Newcastle are the Conservators, took place to-day. Considerable preparations had been made, in order to give proper effect to the aquatic procession, particularly by the stewards of the incorporated companies, who, in testimony

Opposite: Scotswood Road Bridge.

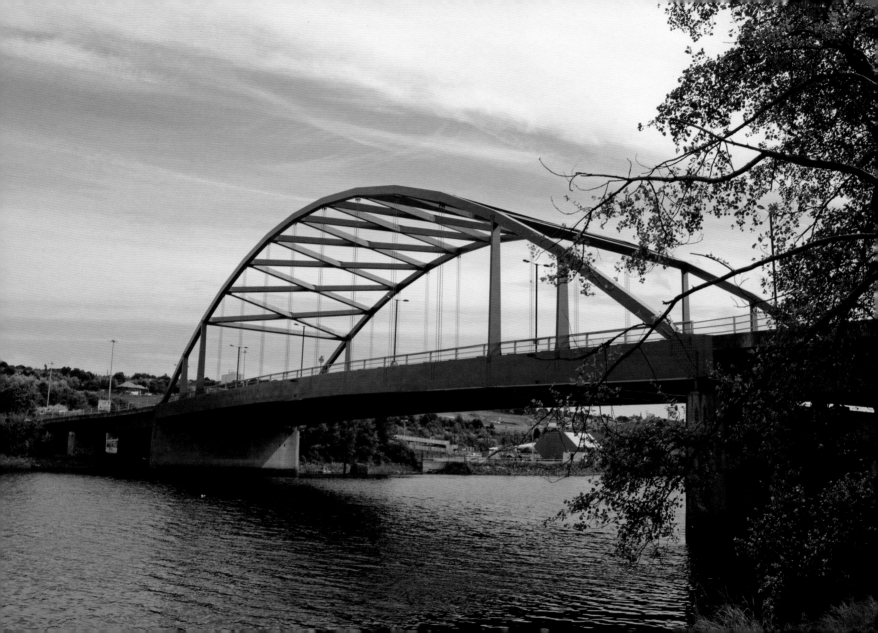

of their approbation of the general conduct of Henry Bell, esq., the mayor, unanimously resolved to join the procession. They engaged the steamer *Swan*, and had it superbly decorated and fitted up for their reception. There was also in the procession a keel, rowed by twenty-four oars, beautifully decorated. The mayor and the river jury sported new barges, expressly made for the occasion; and when the procession started from the Mansion-house at six o'clock in the morning, the spectacle was indeed a very imposing one. On arriving at Shields the party went on shore, and partook of a sumptuous breakfast. After passing the usual boundary, the procession returned to Newcastle, and landed at the Mansion-house, where, during a brief stay, refreshments were partaken of, and the party again went on their journey to Hedwin Streams, the western boundary of the Conservators. At this place the usual festivities were kept up. On the return journey a halt was made at the King's Meadows, where horse-racing and other sports were indulged in. A party of strangers erected a booth on the island, which they termed 'The Liverpool Club House', supposed for the purpose of gambling, and evidently purposed making a rich harvest out of the occasion. They were, however, in this respect, woefully disappointed, as the booth was torn to threads by the populace, and thrown about the green; and it was rumoured that the speculators were losers to the amount of about £20. Two very serious accidents occurred during the day – one to a sailor who was rigging a flag in honour of the occasion, and the other to a man who was firing cannon, and who had his hand severely injured – but beyond this a very enjoyable day was the result of the outing.

Dunston Coal Staithes

Located on the south bank of the Tyne are the Grade II listed and Scheduled Ancient Monument Dunston Coal Staithes, which are currently undergoing restoration. A staithe is a structure on a river bank which allows ships to dock, load and unload cargo.

Built for the North Eastern Railway in 1890, the structure enabled trains carrying coal from the Durham coalfields to discharge directly into the holds of waiting colliers. Three colliers could berth at the staithes. The colliers were ships designed specifically for carrying coal as cargo. Much of the coal loaded at Dunston was used to supply London and these colliers would travel up and down the east coast of England on a regular basis until the closure of the staithes in the 1970s. The staithe is 1,700 feet (518 metres) long and 66 feet (20 metres) above the Tyne and is claimed to be the largest wooden structure in Europe.

The staithes were restored in the 1980s when it was used as a feature for the National Garden Festival held in Gateshead in 1990. Unfortunately, the staithes were then damaged by fires in November 2003 and again in July 2010. The 2003 arson caused a section of the structure to collapse. However, the Tyne & Wear Building Preservation Trust (TWBPT) now own the staithes and with the help of the Heritage Lottery Fund and other partners are undertaking a restoration project which will ultimately lead to the structure being transformed into a sustainable visitor attraction as well as preserving a piece of Tyneside heritage.

Newcastle upon Tyne

When I visit a village or town I always ask myself, 'why is this here?' In the case of Newcastle, the reason for its existence is very much rooted in the fact that it stands on the Tyne. In such circumstances, the 'what if?' question is asked; if it wasn't for the Roman invaders having to cross the Tyne on their way to build Hadrian's Wall, would the city exist?

The Romans built their bridge in *c.* AD 122, which was known as Pons Aelius (Aelian Bridge) and subsequently built a protective fort on a cliff top on the north bank. As was common, a village (*vicus*) arose around the fort with local inhabitants supporting the Roman troops, which would be the start of a permanent settlement. Historically, the remains of a Bronze Age roundhouse were discovered by an archaeological excavation in Newcastle, but this may well have been used by nomadic early Britons.

The Tyne was the lifeblood of Newcastle, with early housing forming around its riverside and its waters being used to transport goods. There have been examples of Stone Age wooden canoes excavated from the banks of the Tyne, so this was probably the earliest form of transport. The Romans used the river to transport goods and personnel from their forts built further downstream at Segedunum and Arbeia. Newcastle itself was to become a port in its own right, although it ceased to be so in the late 1960s. In later centuries the river was used to export huge quantities of wool and coal.

It has to be said that the river at Newcastle was much mistreated in the past, being used as a place to throw rubbish and human waste, with many sewers discharging directly into the Tyne. It was quite common for the stench from the river

Dunston Staithes.

to be noticeable throughout the city in the summer months, but that was cured from the 1960s onwards when the Tyne Interceptor Sewerage Project diverted all sewers to a treatment works downstream at Howdon. The river is much cleaner these days and it is common to see anglers fishing at Newcastle.

River Escapes operate sightseeing river cruises from Newcastle's quayside and it is an ideal way to see the Tyne. Cruises are operated from Newcastle to the mouth of the Tyne and also up stream to the west in the direction of Newburn.

Newcastle upon Tyne and Gateshead Crossings

Seven bridges cross the Tyne between the city of Newcastle upon Tyne and its neighbour, Gateshead. I often ask the trick question, 'which United Kingdom town has the same number of bridges as Newcastle?' It is, of course, Gateshead.

Travelling from the west the first bridge is the Redheugh Bridge, which is the third bridge at that site, the first opened in 1871, the second in 1901 and finally the present bridge in 1983. Before the 1871 bridge, a ferry operated to carry passengers across the Tyne. Both of the pre-1983 bridges charge a toll and this was ended when the Newcastle and Gateshead corporations purchased the bridge from private ownership in 1937. The toll house on the southern bank remains and is now a residential property. The present bridge was built 82 feet (25 metres) to the east of the 1901 bridge. The 1901 bridge remained in use during the building of the new crossing to avoid any disruption to traffic. Following the completion of the replacement in 1983 it was demolished. The designers of the present bridge were Mott, Hay & Anderson, with the architect being Holford Associates and the main building contractor Edmund Nuttall Ltd. The bridge is constructed using pre-stressed, post-tensioned concrete box cells which carry various utilities such as water mains, gas pipes and electricity cables. The box design also allows for accessible inspections of its structure, which has been designed to last for at least 120 years. The length of the bridge is 2,884 feet (879 metres) and has a width of 52 feet (15.8 metres); it carries four lanes of traffic and has a pedestrian path on its western side. It is able to carry transport carrying abnormal loads of up to 4,000 tons, but it is quite often closed to high-sided vehicles due to its exposed position to winds. The bridge was officially opened by Diana, Princess of Wales, on 18 May 1983. It cost just over £15 million, including £2 million spent on the demolition of the old bridge.

Next is the Grade II listed King Edward VII Bridge, which carries four rail lines across the Tyne. Built by the North Eastern Railway to alleviate heavy volumes of rail traffic using the High Level Bridge, original plans for its design had to be changed when old coalmine workings were discovered. Erected between 1902 and 1906 to a design by Charles A. Harrison (1848–1916), Chief Engineer of the North Eastern Railway, the main contractor was the Cleveland Bridge and Engineering Co. of Darlington. The bridge is formed from four lattice girders supported on five piers, with a total length of 1,150 feet (350 metres), is 50 feet (15 metres) wide and is 112 feet (34 metres) above the waters of the Tyne. Costing £500,000, the bridge was officially opened by King Edward VII on 10 July 1906. I always find it somehow reassuring when travelling back to Newcastle from the south and seeing the Tyne Bridge from the train window when crossing and thinking, 'I'm home'.

The Queen Elizabeth II Metro Bridge caries the Tyneside Metro rapid transport system, with trains passing between Newcastle upon Tyne and Gateshead. It was built between 1976 and 1980 to a design by W. A. Fairhurst & Partners, with the main contractors being Cementation Construction Ltd, Cleveland Bridge & Engineering Co. Ltd and Hawthorn Leslie and Co. Ltd. Built in two sections at the same time – one from the Gateshead bank and the other from Newcastle – it is made from steel, its sections prefabricated and then brought on to the site to be bolted together. A total length of 1,181 feet (360 metres) and a width of 34 feet (10 metres), it carries two tracks.

Costing £6 million, it was officially opened by Her Majesty Queen Elizabeth II, accompanied by the Duke of Edinburgh, on 6 November 1981.

The Grade I listed High Level Bridge is the oldest of the seven bridges, having been completed in 1849. Designed for the York, Newcastle & Berwick Railway by Tyneside-born Robert Stephenson (1803–59) and London-born Thomas E. Harrison (1808–88), it is a bridge which carries two decks, the lower one for vehicular traffic and the upper for trains. This was the first railway crossing between Newcastle and Gateshead. Before it opened, passenger services terminated in Gateshead and had to cross the Tyne by road to join a train at Newcastle station for their onward journey north. The builder of the bridge was the Gateshead firm Hawks of Crawshay. One aspect of the construction of the bridge was the displacement of housing on both banks of the Tyne; 650 Newcastle and 130 Gateshead families had their homes demolished. The bridge is supported on six piers built into the river bed, reaching a height of 112 feet (34 metres) above the water level; it has a total length of 1,337 feet (408 metres). The bridge opened to rail traffic on 15 August 1849 and road on 4 February 1850. The official opening of the bridge had to wait until 28 September 1849 when Queen Victoria carried out the opening, albeit while sat in her carriage which had halted. The bridge was strengthened in 1922 to accommodate the use of trams to cross the river, but major restoration was carried out between 2005 and 2008. Major faults were found during the latter works; hardly surprising when you consider that it was originally built to carry horse-drawn transport. One result was that on reopening in 2008, traffic using the road deck is now restricted to buses and taxis only travelling in one direction from Newcastle to Gateshead, designed to alleviate the weight load. The bridge is open to pedestrians, with walkways on both sides and affording good views over the river. An interesting event occurred during the building of the bridge, captured by Thomas Fordyce in his Local Records on 28 July 1849.

> Whilst a carpenter, named John Smith, of Newcastle, was at work on the High Level Bridge, he stepped upon a loose plank, which immediately canted over, and he was thrown headlong over the bridge. In his descent, however, the leg of his fustian trousers caught a large nail, which had been driven into the timber just above the level of the lower roadway 90 feet above the river, and what is very remarkable, he hung suspended until some of the workmen rescued him from his perilous situation. Whilst John Smith was lucky in his High Level Bridge accident, he was to meet his death 29 years later when in 1878 he fell into the hold of a ship and died of his injuries.

The Grade II* listed Swing Bridge was built between 1868 and 1876. As its name suggests, the bridge rotates 360 degrees to permit river-borne vessels to pass. The bridge is close to the site of Tyne's most historically important bridges. It was near here that the Romans, in c. AD 122, built their crossing known as Pons Aelius (Aelian Bridge). The Swing Bridge replaced the Mylne Tyne Bridge of 1781, which, owing to its low arches, was interfering with navigation to the higher reaches of the Tyne. The main driving force behind the replacement of the bridge was that W. G. Armstrong & Co. of Elswick wanted to expand its operation to fit guns to warships; to achieve this, the low arched bridge had to go. The newly formed Tyne Improvement Commission agreed to the replacement of the bridge and

W. G. Armstrong & Co. was awarded the contract to build the replacement with an innovative hydraulically powered swinging bridge. The hydraulics centre upon an accumulator, which is accommodated in a 60 foot (18 metre) shaft sunk into the river bed. Water is pressurised within the accumulator and then released to drive the machinery turning the bridge. The road deck of the bridge has a total length of 560 feet (171 metres) and is 48 feet (15 metres) wide. The bridge carries a two lane road as well as pedestrian pathways on each side. Completed in 1876, there was no opening ceremony, which, given its importance, I have always thought to be strange. Statistically, the bridge was opened 6,000 times in the peak year of 1924. However, with the cessation of equipping warships at Armstrong's Elswick Works and the closure of Dunston Staithes, vessels needing to pass the bridge became rare and these days it rarely opens for the purpose for which it was originally built. The bridge is owned and managed by the Port of Tyne; it is still manned 24 hours a day and is opened once a month for maintenance purposes. It is also a very popular attraction during the annual Heritage Open Days when the public are given conducted tours.

To many, including myself, the New Tyne Bridge is the iconic symbol which represents Newcastle upon Tyne. A road bridge carrying four lanes of traffic, it also has pedestrian pathways to each side and is the main road route between Newcastle and Gateshead. At one time it carried the A1. There is often reference to the Tyne Bridge being a model for the Sydney Harbour Bridge, but this is incorrect. Both bridges are similar in design and both were constructed by Dorman Long. However, the building of the Sydney Harbour Bridge was commenced in 1923 and completed in 1932 while the Tyne Bridge was built between 1925 and 1928. The engineers for the Tyne Bridge were Mott, Hay & Anderson, with the architect being Newcastle based R. Burns Dick (1868–1954). One of the demands placed on the architect was the requirement imposed by the Tyne Improvement Commission that the bridge should not interfere with the navigation of vessels on the Tyne. This resulted in a single span, two-hinged steel arch being erected. The design meant that there were no support piers in the river and the distance above the water of 84 feet (25.5 metres) was sufficient for the largest of ships to pass with ease. At the time of its construction it was the largest single span steel arch bridge in Britain. The bridge is supported on Cornish granite faced pylons, which, while designed to contain five-storey warehouses, they were never used as such. The pylons also contained a pedestrian lift at both sides of the river, but these are no longer in use. The bridge was opened by King George V on 10 October 1928, although various works at the Gateshead side of the bridge had not been completed. The total length of the bridge is 1,276 feet (389 metres), the single span measures 53 feet (162 metres) and the width is 56 feet (24 metres)

Opposite: Newcastle bridges, looking east.

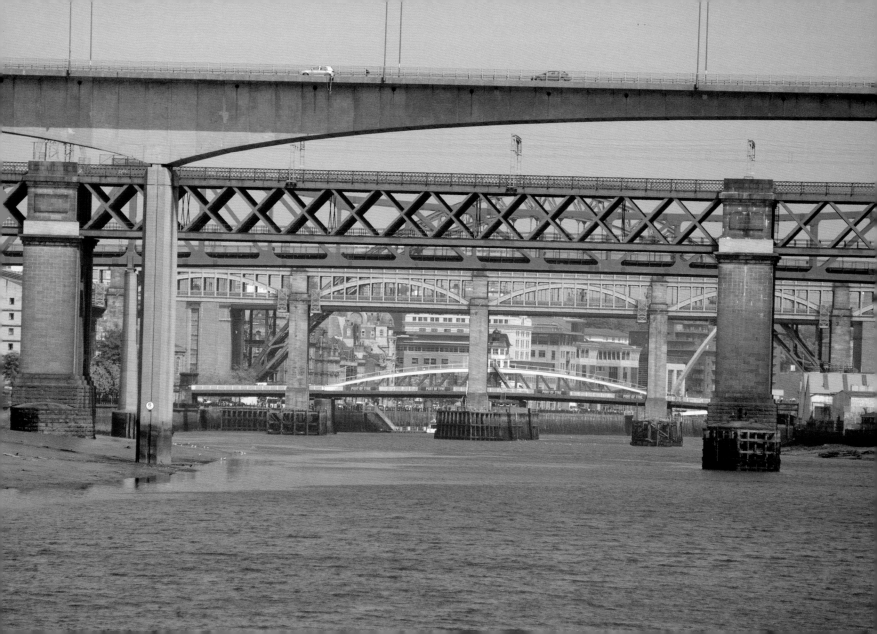

The Gateshead Millennium Bridge is the newest of the seven bridges, having been installed in 2000, opened to the public in 2001 and officially named by Her Majesty Queen Elizabeth accompanied by the Duke of Edinburgh on 7 May 2002. The bridge was built to celebrate the new millennium and Gateshead Borough Council partnered with the Millennium Commission and the European Regional Development Fund to raise the £22 million required for its construction. Designed by the architects Wilkinson Eyre, the bridge tilts and is nicknamed the 'Blinking Eye Bridge'. The bridge was constructed by Volker Stevin further down the river towards the east at Howdon and transported up river by the Asian Hercules II floating crane on 20 November 2000, when it was lowered into place. It carries pedestrians and cyclists only and is tilted to allow yachts and other vessels to pass underneath. It is also opened throughout the year to entertain tourists. The tilting mechanism is powered by electricity and takes four-and-a-half minutes to open to its full 40 degrees and was rotated for the first time on 28 June 2001. The length of the bridge is 413 feet (126 metres). The bridge is illuminated at night and has the capacity to change colours.

Opposite: Newcastle bridges, looking west.

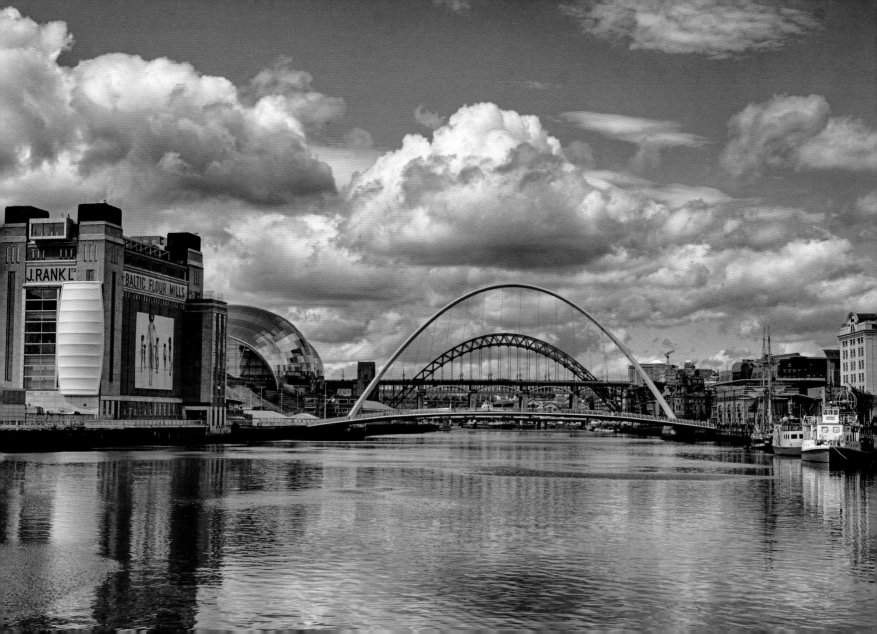

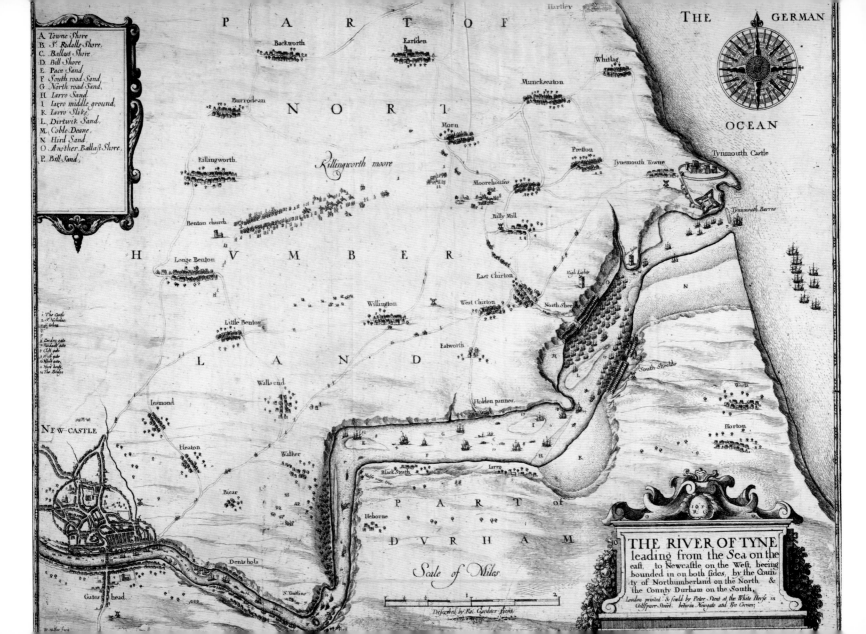

PART OF THE GERMAN

A Towne Shore
B S.t Rdalls Shore
C Ballast Shore
D Bill Shore
E Pace Sand
F South road Sand
G North road Sand
H Iarro Sand
I Iarro middle ground
K Iarro Slike
L Dirtwyk Sand
M Coble Doane
N Hird Sand
O Another Ballast Shore
P Bill Sand

Hartley
Backworth
Earsden
Whitlay
Munckseaton
Burrodean
NORT
Morn
Preston
Tynmouth Castle
Killingworth
Killingworth moore
Moorehouses
Tynemouth Towne
OCEAN
Benton church
Billy Mill
Tynmouth Barres
Longe Benton
H U M B E R
East Chirton
High Light
N
Little Benton
Willington
West Chirton
North Shee
1 The Castle
2 S.t Nicholas
6 Pandon gate
7 Sandhill sate
8 Cloft gate
9 West gate
10 River gate,
a Youre house,
12 The Bridge
L A N D
Eatworth
South Sheelds
Walls end
Holden pannes
Works
Iesmond
Horton
NEW-CASTLE
Heaton
Walker
Black Steath
Iarro
Bicar
PART of DVRHAM
Heborne
Scale of Miles
Dents hola
Gates head
S.t Austine

THE RIVER OF TYNE
leading from the Sea on the
east, to Newcastle on the West, beeing
bounded in on both sides, by the Coun
ty of Northumberland on the North &
the County Durham on the South,
London printed & sould by Peter Stent at the White Horse in
Gilspurr Street betwixt Newgate and Pye Corner

W. Hollar fecit
Deseribed by Ra: Gardner Gent.

St Peter's Marina

Less than a mile from Newcastle Quayside is the St Peter's Marina, occupying the former St Peter's Dockyard in which a number of wooden vessels were built in the years from 1813 to 1861 by Thomas and William Smith. Large sailing ships, known as East Indiamen, were built for the trade with the Far East and India. In 1863, the yard was taken over and became the St Peter's Iron Shipbuilding Co. and was ultimately acquired as part of the Hawthorn Leslie works. Those industries have now gone and a modern marina surrounded by residential housing it was developed in the 1980s. The marina is also home to a number of restored historical fishing boats.

Felling – International Paints

In 1904, Max and Albert Holzapfel, together with Charles Petrie, opened a factory at Felling on the south bank of the Tyne which produced marine paints for the shipping industry under the trade name of Holzafel's Compositions. The factory continues to produce specialist marine paints and these days is owned by AkzoNobel and trades as International Paints.

Above: St Peter's Marina.

Opposite: Peter Stent seventeenth-century map, by kind permission of the librarian at Robinson Library, Newcastle University.

Offshore Technology Park

The north riverside of the Tyne which runs from Walker through to Wallsend is currently undergoing a renaissance, changing from the now long gone shipbuilding yards to embrace new technologies, mainly connected with the offshore industries.

One such example is the firm of Technip, which operate an umbilical manufacturing facility on the site of the former Walker Naval Yard, which in the past was famous for building many First World War warships. A reminder of the yard is the Hammerhead crane that has stood since 1930 and is still in use to load and unload reels of cables directly onto ships berthed at the 2,625-feet-long quay frontage. The crane was built by Sir William Arrol & Co. and could originally lift loads of 250 tons. However, following an overhaul in 2012 its capacity has been increased to 320. A smaller crane is carried on the superstructure which provides a lifting facility during maintenance work.

Above: Offshore Technology Park.

Opposite: International Paints, Felling.

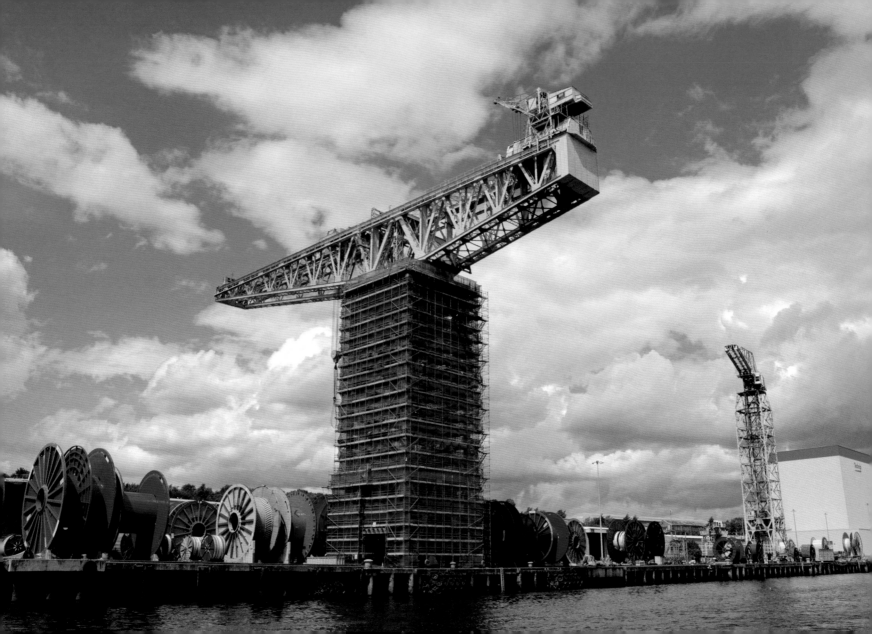

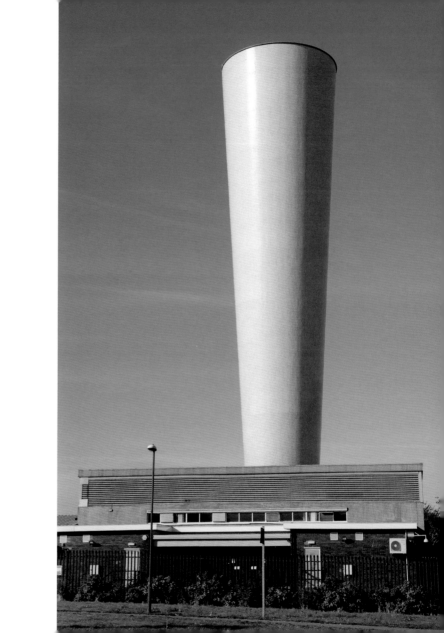

Right: Ventilation funnel, Tyne Tunnel.

Opposite: Offshore Technology Park.

Tyne Pedestrian and Road Tunnels

The Tyne isn't only crossed by bridges. There are four tunnels between Howdon and Jarrow, comprising a double vehicle, one pedestrian and one for cyclists. For many years it had been discussed that a crossing point closer to the mouth of the Tyne would not only save the residents in that part of Tyneside an easier way of crossing the river, but to also ease the traffic passing through Newcastle. Discussions on what form the river crossing would take were debated for many years; would it be a bridge or a tunnel? The answer was the latter. While not having a river crossing, the lower parts of the Tyne were well served by a number of ferries. Indeed, a ferry transporting pedestrians between North and South Shields still exists.

The first of the tunnels to be built was the now Grade II listed pedestrian and cyclist tunnel, which commenced in June 1947 and was completed in July 1951 at a cost of £900,000. The main contractor was Charles Brand & Sons Ltd under the supervision of Sir David Anderson (1880–1953) of Mott, Hay & Anderson. The tunnels are 900 feet (274 metres) long, one with a diameter for pedestrians of 11 feet (3 metres) and the other 12 feet (43.7 metres). They lie 40 feet (12 metres) below the river bed. The tunnels are tiled in pale green and yellow glazed tiles which were installed by Carter & Co., which became part of Pilkington Tiles in 1964. At the time of writing, the tunnels have been closed for a £4.9 million refurbishment since 2013 and work continues with a proposed reopening in 2016.

There are now two vehicle Tyne tunnels. The construction of the original tunnel commenced on 9 October 1961 with the main contractor being Edmund Nuttall & Sons Co. Ltd. While the pedestrian tunnel is toll free, it was decided that the road tunnel would have a toll which would help to pay for the £12.5 million costs of construction. Those tolls are still applied. The tunnel was opened by HM The Queen Elizabeth II on 19 October 1967. The tunnel is 1 mile (1.6 kilometres) in length, has a diameter of 31 feet (9.5 metres) and is 24 feet (7.3 metres) beneath the river bed.

A second Tyne tunnel was built to alleviate the increased levels of traffic travelling through Tyneside and lies parallel with the original tunnel. HM The Queen Elizabeth II returned to Tyneside to officially open the new tunnel on 18 July 2012, around forty-five years after she had opened the first. Construction of the new Tyne crossing commenced in July 2005 and was built in a completely different way to the original tunnel. Instead of cutting a way underneath the river bed using a traditional boring and digging technique, the new tunnel was built from pre-cast concrete sections which were placed in a trench cut into the bed of the Tyne.

Traffic now uses the new crossing to travel from north to south and the original tunnel is used in the opposite direction. Consequently, there is rarely heavy congestion for vehicles wishing to cross the Tyne.

Jarrow – St Paul's Monastery

Located on the south bank where the River Don feeds the Tyne are the remains of the Abbey of St Peter and St Paul at Monkwearmouth, Jarrow. This is one of two monasteries and churches which were located at Jarrow and at Monkwearmouth (Monkwearmouth is now part of urban Sunderland). St Paul's church at Jarrow and its associated monastery was built in

AD 681 on land gifted by King Ecgfrith of Northumbria to the Anglo-Saxon abbot Benedict Biscop (628–90). The religious site is perhaps more famously known for its association with the Venerable Bede (673–735), the author and scholar.

The Grade I listed church of St Paul's remains and is open daily. However, the Grade I listed SAM monastery leaves much to the imagination, as only parts of it remain today. It is set out in stones to indicate where the major walls were situated, which help to develop a picture in the mind. The monastery was attacked and sacked by Viking invaders in 794 and destroyed by the Danes in 860. In the eleventh century, the Bishop of Durham, William Walcher, ordered the monastery to be rebuilt, however the building was later to be torn down during the Dissolution of the Monasteries.

Near to the church and monastery is Bede's World, which is a museum dedicated to the life of the Venerable Bede. Additionally, the museum has an 11-acre reconstruction of an Anglo-Saxon farmstead with animals and crops representing the period in time.

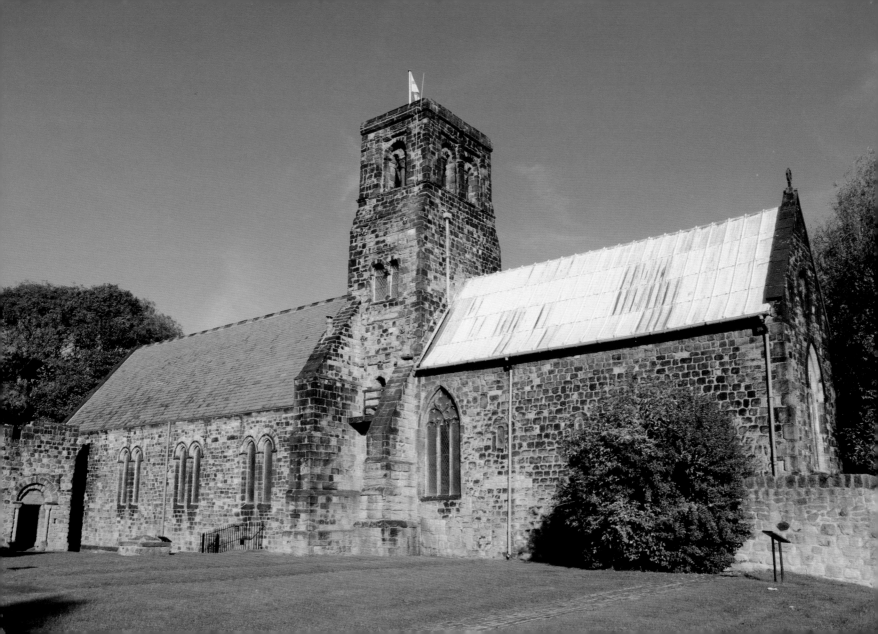

Port of Tyne

The Tyne has been used as a port since the second century, when the Romans built their fort of Arbeia at South Shields and used its riverside position as a harbour. Today, the Port of Tyne Authority is the navigational authority for the length of the river from its mouth to the tidal stone at Wylam. It also operates cargo handling on both banks of the Tyne, mainly towards the west of North and South Shields. Its main site is based around Tyne Dock, which is the name of an area of South Shields. Until recent times, there was an actual dock with that name, but owing to advances in modern shipping it became too small to handle large vessels and was consequently filled in. Part of the material used for that purpose came downstream from the work carried out during the digging of a trench for the new Tyne tunnel.

Once famed as a major exporter of coal, the saying 'coals from Newcastle', is now an idiom meaning superfluous or a pointless action. However, the last coal loading facility on the river was demolished in the 1970s and now the Tyne is an importer of coal from Eastern Europe and the Americas. The modern-day imports are loaded onto trains at the port and taken by rail to the electricity power stations of South Yorkshire. The port also handles biomass cargo (wood pellets) which is used to fire the South Yorkshire power stations, considered to be a cleaner and sustainable source of fuel. This cargo came in from Vancouver, Canada.

The port also handles the import and export of vehicles via three dedicated car terminals, two on the south bank and one on the north. The nearby Washington based Nissan factory exports its manufactured cars through the port and this makes it the largest car exporter in the UK, handling around 600,000 cars per annum.

Other cargo handled is bulk volumes of steel, grain and container traffic. At the time of writing, the port is undertaking a £25 million expansion to increase its water frontage to increase its Riverside Quay by 338 feet (100 metres) and allow the berthing of more ships.

Opposite: St Paul's, Jarrow.

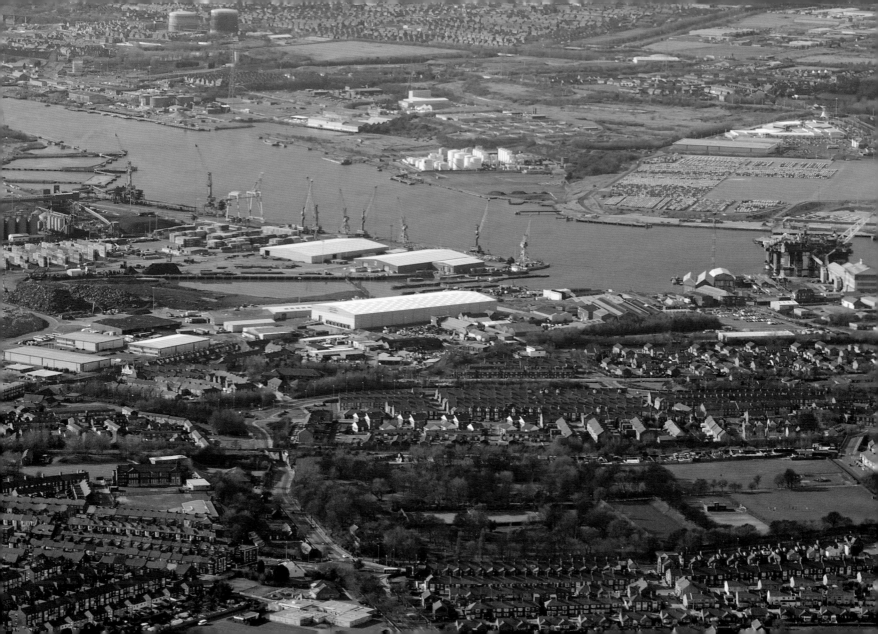

North Shields

The town of North Shields is located on the north bank of the Tyne. Its name is derived from the Old English *scheles or shiels*, translated as huts or shelters. It is thought that the name indicates the early habitation of fishermen living in huts where the Pow Burn enters the Tyne when the priors of Tynemouth granted occupation of their lands in 1225. It is around this area that the fishing port developed and sea fishing on a commercial basis is still a major source of employment in the town. Although, with the general decline in the industry it is not as large as it was in previous centuries.

In the past, navigation into the Tyne has was supported by four Grade II listed lighthouses, all of which still exist: three have been converted into residences and the other into a recently opened heritage centre. The reason for so many lighthouses is that navigators coming into the Tyne would line up two lights, one called the High Light and the other the Low Light. When the two lights were aligned it was safe to follow that course into the river, thus avoiding some natural obstructions at the mouth of the river, such as the notorious Black Midden Rocks which claimed many an unwary vessel. Unfortunately, due to changes in tide flows, the earlier lighthouses fell out of use with new ones being erected. The most noticeable lighthouse is the New High Light, which commands the view from a high bank overlooking the fish quay. The oblong white painted building was erected in 1808 for Trinity House, Newcastle upon Tyne, with the attached house being added in 1860 when the lighthouse was rebuilt.

The town continues with its long association with seafaring. To the west is the Port of Tyne International Passenger Terminal, which serves a daily link with Ijmuiden in the Netherlands, operated by DFDS. Additionally, the terminal sees a number of visiting cruise liners in a season running between spring and autumn. A cross-Tyne ferry operated by Nexus transits the river between North and South Shields with a regular daily service.

Opposite: Port of Tyne aerial view.

Overleaf: North Shields Fish Quay, old postcard view.

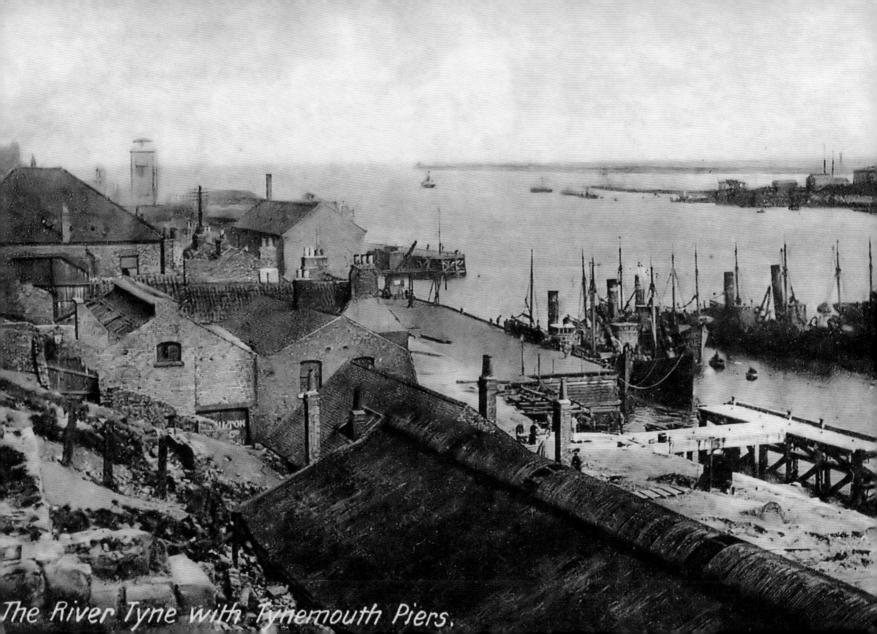

The River Tyne with Tynemouth Piers.

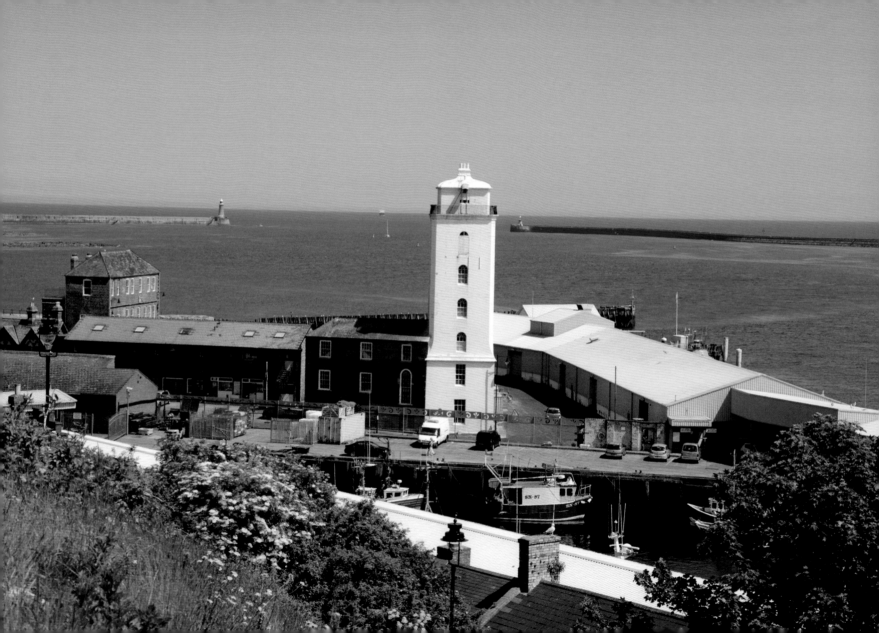

South Shields

On the opposite side of the bank from North Shields is its neighbour of South Shields – both share the same historical link to sea. As previously mentioned, the fort Arbeia was built by the Romans in the second century to protect the mouth of the Tyne and the harbour, which had been erected as a staging point for ships carrying building materials, goods and troops for Hadrian's Wall. Ships were prevented from travelling further upstream due to its shallow nature and shallow draft barges were used to transport materials and personnel further upriver toward the Segedunum fort at Wallsend and on to Newcastle. The name 'Arbeia' means 'place of the Arabs' and is thought to refer to the Tigris boatmen who were garrisoned here and navigated the barges. The site of the fort has seen many archaeological excavations and is now open as a museum from spring to autumn. A replica of a gateway which may well have stood at the fort has been reconstructed on its original footprint and gives an impressive view when entering the museum.

Overleaf: North Shields Fish Quay, modern view.

Opposite: Arbeia Fort.

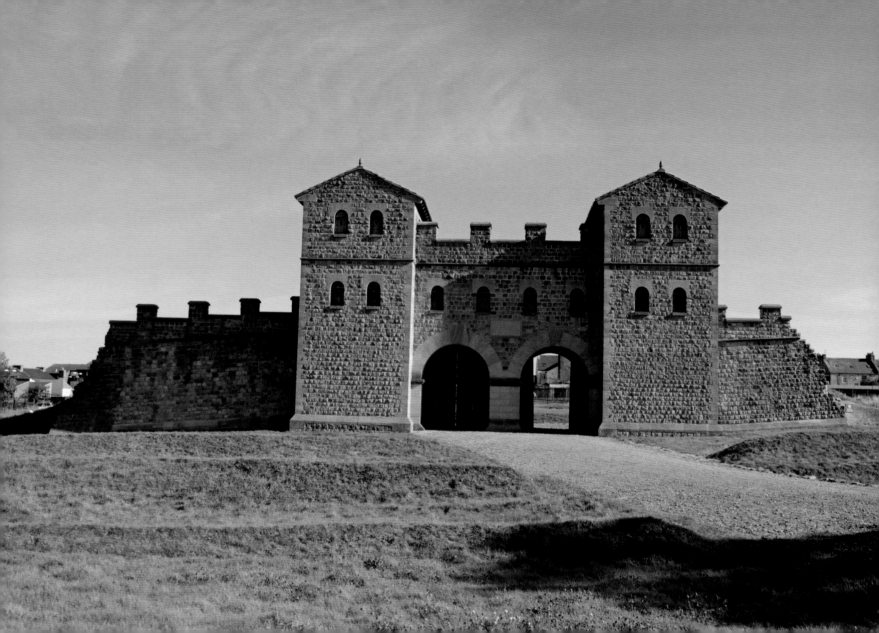

As well as being a port, the town was very much an industrial area the nineteenth century. It had its own coalmine, shipyards, alkaline production and glass making works among others. John Readhead & Sons was the town's largest ship builder, but this closed in 1984. Nowadays there are only two small boat repair slipways in South Shields. The colliery at Westoe closed in 1993, the mineshafts had extended for 7 miles (11 kilometres) under the North Sea in the search for coal.

South Shields is also the location where a competition to invent the rescue lifeboat was fought out between local man Henry Francis Greathead (1757–c. 1810) and North Shields born William Wouldhave (1751–1821). Both men claimed to have invented the purpose-built lifeboat, but it is also considered that both may have been beaten to that title by Essex-born Lionel Lukin (1742–1834). A Grade II listed memorial tower and clock to both Greathead and Wouldhave stands close to the seafront on Ocean Road, erected during the Jubilee year of Queen Victoria in 1887. Designed by North Shields-born architect J. H. Morton (1849–1923), it is 45 feet (13.7 metres) high, designed in a Classical style. It has a relief on each face – portraits of Greathead and Wouldhave – and two reliefs of a lifeboat carrying out a rescue from a wrecked ship. The memorial bears this inscription: 'Erected in commemoration of Jubilee of HM Queen Victoria June 20th 1887, as a memorial of the beneficent work of the lifeboat as designed and built in South Shields in year 1790'. Adjacent to the memorial is a lifeboat, the *Tyne*, built in 1833 and which served as a lifeboat for more than sixty years, saving over 1,000 lives. Both the lifeboat and its canopy have been recently restored and are Grade II listed.

Opposite: Lifeboat memorial.

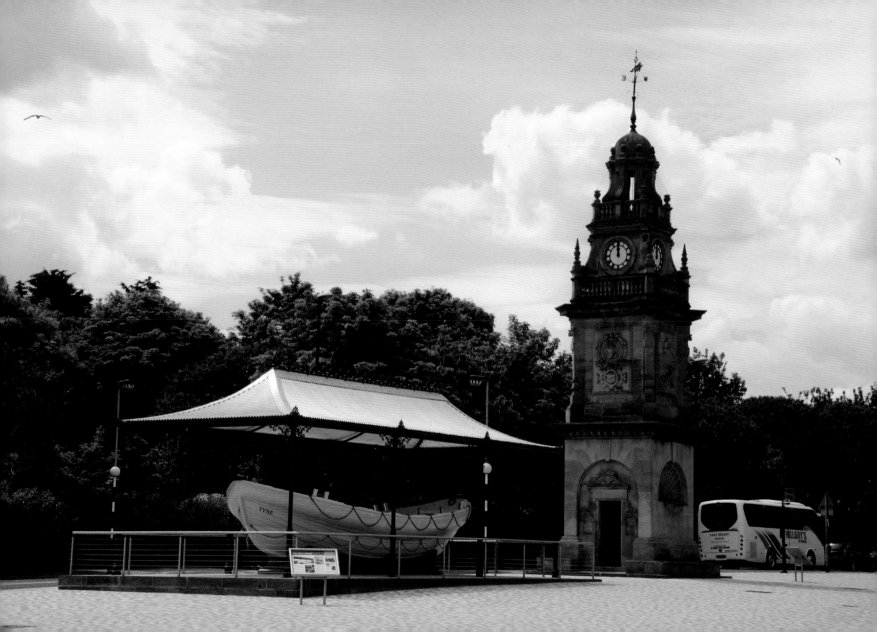

Tynemouth

The town of Tynemouth stands on the north bank of the river and the name is self-explanatory as it is located at the mouth of the Tyne. In AD 792 it was known as 'Tinan muthe'. Though a town, Tynemouth has the feeling of being very much a village, with most shops and pubs surrounding Front Street and no industry to speak of. It is a commuter town, with many residents travelling to Newcastle upon Tyne via the Tyneside Metro rapid transport system.

The headland overlooking the North Sea is known as Pen Bal Crag and has been occupied since the Iron Age. There is also suggestion that the Romans may have had a small fort here, although no archaeological evidence has been located. A monastery was erected in the seventh century, which later became Tynemouth priory. It is claimed that three kings are buried in the grounds of the priory: Oswin King of Deira (651); Osred II King of Northumberland (792); and King Malcolm III of Scotland (1093). The three kings are represented within the coat of arms for the Borough of North Tyneside in which Tynemouth is included. In the ninth century, the monastery was destroyed by the Danes and lay abandoned until a castle was built around it in the eleventh century. In the same century, the monastery was rebuilt as a priory which lasted until 1538 when the Dissolution of the Monasteries caused its partial destruction and closure. Both the castle and remains of the priory are under the guardianship of English Heritage and are open to the public throughout the year. The religious buildings' ruins are well worth a visit, as are the great sea views and the sizeable graveyard containing many weathered headstones.

In the nineteenth century, the castle grounds were used as a military barracks and became a coastal gun battery during the Second World War, giving protection to the entrance of the Tyne. The grounds also house a coastguard station. Built in 1980, the station closed in 2001 but the building remains.

Opposite: Tynemouth priory and castle.

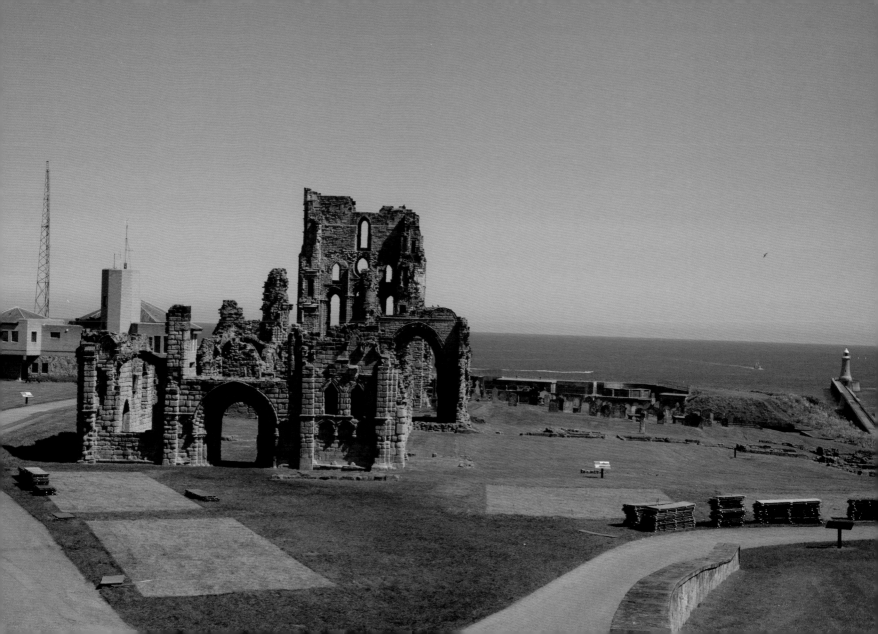

Also standing in Tynemouth is the Grade II* listed Collingwood Monument. Located on high ground overlooking the river, it is a testimonial to Newcastle-born Admiral Lord Cuthbert Collingwood (1748–1810). Collingwood's fame is that he took over command of the Battle of Trafalgar (October 1805) when Admiral Lord Horatio Nelson (1758–1805) was mortally wounded. The monument was built in 1845 and paid for by an appreciative public; it was designed by architect John Dobson with the statue being sculptured by John Graham Lough (1796–1876). The four cannons at the base of the monument were from Collingwood's ship at Trafalgar, *The Royal Sovereign*, and certainly give the impression that the Admiral is guarding the Tyne.